IMAGES
of America

FOUNTAIN VALLEY

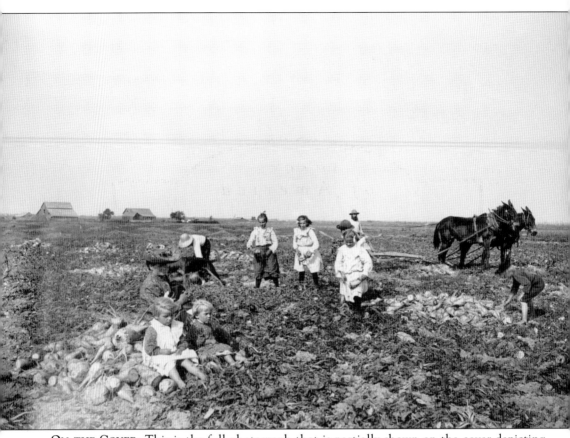

ON THE COVER: This is the full photograph that is partially shown on the cover depicting the Kozina family, taken around 1910 near Newhope Street. Jacob and Mary Kozina, Czech immigrants, are with their kids helping to harvest the sugar beets. They would deliver the beets by horse-drawn wagons to a sugar factory in a neighboring town. The larger farms used labor camps of migrant workers or locals from other farms, and children started working on farms at an early age. Note the two children sitting in the foreground without shoes, a common sight for the time. (Courtesy of Orange County Archives.)

IMAGES
of America

FOUNTAIN VALLEY

Daniel Aaron Gibb

ARCADIA
PUBLISHING

Published by Arcadia Publishing
Charleston SC, Chicago IL, Portsmouth NH, San Francisco CA

Printed in the United States of America

Library of Congress Catalog Card Number: 2006941041

For all general information contact Arcadia Publishing at:
Telephone 843-853-2070
Fax 843-853-0044
E-mail sales@arcadiapublishing.com
For customer service and orders:
Toll-Free 1-888-313-2665

Visit us on the Internet at www.arcadiapublishing.com

*This book is dedicated to my wife, Laura, and my daughters
Cambria Shannon and Paula Douglas. It has been as enjoyable bearing
witness to their lives as it has been having my parents bear witness to mine.
This is also dedicated to my parents, Dennis Lee Gibb of Biggsville, Illinois,
and Ruth Ann (Bowman) Gibb of St. Anthony, Iowa, for not only putting
down roots in Fountain Valley when my brothers Mike, Todd, and I were
young, but also for providing the best possible childhood anyone could ask for.
I love them dearly.*

CONTENTS

Acknowledgments 6

Introduction 7

1. A Community Becomes a Town: Pioneers and Settlers 9

2. Taming the Water, Farming the Land 31

3. The Town Becomes a City: The Master Plan 59

4. Flight 73

5. Schools, Churches, and Parks 87

6. Odds and Ends 109

ACKNOWLEDGMENTS

This project could not have been possible without the help of many people. First and foremost, I want to thank Phil Brigandi, the Orange County archivist, and his assistant, Chris Jepsen, for their knowledge and materials. Their help was invaluable. I would also like to thank Todd Gibb and George Turlis of Boss Industries, and Arcadia Publishing's Jerry Roberts.

Fountain Valley's early farming families and residents who opened their family photo albums include Hazel Courreges and her daughter Janice; Joe "Louis" Betschart; Nellie and Vicky Calderon; Jim Kanno; Lillian Sasaki and her mother, Suzie Kato; Kathy Wardlow, whose mother Evelyn, a longtime Fountain Valley historian, passed away just before this project started; Earl Lamb; Mrs. Charles Ishii; Penny Fujimura; and "Mas" Masuda. Thanks also go to members of the Fountain Valley Historical Society, including Pres. Lillian Garcia, Blanche Weaver, Ruben and Connie Alcala, Jan Tubbiola, Helen Ditte, Frank and Ysabel Lucero, Val Callens, and Wayne Osborne. I would like to extend warm thanks to Darby Templin and Dixie Merrill, Bob Blankman of First American Title Corporation, Evie Belgen of Fountain Valley High School, and longtime resident Ed Arnold of KOCE-TV.

Appreciation goes to several city employees, including engineer Ron Chamberlain of the Fountain Valley Fire Department; Ray Kromer; Robin Roberts; Mary Bowron; Don Heinbuch; Kathy Heard; Adria Paesani; Cheryl Brothers; and last, but certainly not least, the city's first administrator, F. J. "Bud" Klecker. This project has truly been a treasure hunt. While helping me research through my family's history, a friend, Milt Paras, used to always say, "Collect the pieces, lest they be lost." How true.

INTRODUCTION

Fountain Valley is located near the center of Orange County and encompasses 9.8 square miles. It is 30 miles southeast of Los Angeles and less than 5 miles from the beach. Located between the cities of Huntington Beach and Santa Ana, Fountain Valley lies almost entirely within the last wide bend of the historic Santa Ana River, which drains the San Bernardino Mountains and spills into the Pacific Ocean at Huntington Beach. Eventually controlled and redirected by Prado Dam and massive concrete channels, the river has left behind for centuries the true riches of Fountain Valley—fertile alluvial soil and abundant water.

In the late 1700s, the area was part of a land grant given to ex-soldier Manuel Nieto by Spanish governor Pedro Fages. Later it was granted to his daughter-in-law as the Rancho Las Bolsas. In the 1800s, Abel Stearns, a Massachusetts businessman, eventually bought Rancho Las Bolsas as well as other ranchos. This great land baron formed the Stearns Ranchos Company. The Santa Ana River flowed year-round, and the lower portion of this rancho became a swampy area covered with great willow and sycamore trees, tules, and other marsh vegetation.

The area became known as "Gospel Swamp" due to the many evangelistic meetings held in tents. The ample water supply from artesian wells supported extensive farming as well as cattle and sheep grazing. Throughout this area were pockets of dry land, making this landscape a hunter's paradise.

In the late 1800s, a severe draught caused the water table to drop, ruining much of Abel Stearns's cattle business, but revealing rich farmland. Stearns Ranchos Company started selling off portions of land to farmers who recognized the richness of the soil at a time when the great rancho era was coming to an end.

Roch Courreges, who was of Basque heritage and hailed from San Francisco, came to this area in 1878. He bought land on a bluff to raise sheep. Shortly after, R. B. Wardlow of Long Beach bought 160 acres and began to clear the land. Then, in 1896, James T. Talbert, a friend of the Wardlows, also left Long Beach and with his family purchased 320 acres where the community of Fountain Valley would begin to take shape.

On the crossroads of what would become Bushard Street and Talbert Road, a blacksmith's shop was built. Soon came a general store, built by John Corbett, who after just two years, sold the enterprise to Tom Talbert. In 1899, these locals applied for the establishment of a U.S. post office from President McKinley's administration, using the name Fountain Valley. They were told to reapply with a one-word name. It was decided that "Talbert" would be the choice. On November 15, 1899, the Talbert Post Office was established.

The Fountain Valley School District, which had been established for several years, lapsed until 1898. But with more children in the area, the district was reestablished and had its first graduating class in 1903. The first house of worship in the area was the Methodist Church South. Soon after, in 1904, when the land was surveyed and found to be 25 feet above sea level, Talbert Drainage District was formed to control the water, allowing more of the land to be farmed. This caused property values to soar.

In the years that followed, other communities formed in the Fountain Valley area, such as Colonia Juarez in 1923, complete with churches, stores, and a community center. A large Japanese farming community formed as the area transformed from a field-crop sector into a truck-farming community. World War II arrived, and the Japanese families were relocated in internment camps, mostly to the camp in Poston, Arizona. Many returned to their land after the war. During this time, the U.S. government developed an outlying field in the area and called it "Mile Square." U.S. Navy Corsair pilots and trainees used the landing strip to practice for aircraft carrier landings. Later, U.S. Marine Corps pilots used the area for helicopter training. Mile Square became a park in the 1960s and remains one of the largest regional parks in the county.

By the 1950s, neighboring cities, such as Santa Ana and Garden Grove, tried to annex large areas of the town of Talbert. An incorporation committee was formed by residents to make their hometown a city. A vote was taken, and the committee decided to incorporate with the original name of "Fountain Valley." The city and the name were approved by local voters on June 13, 1957. A motivation behind the incorporation was to keep the area a farming community. But with the population explosion and later increased urban flight from Los Angeles as well as increasing land values, the city council decided that development should be as orderly as possible. So Fountain Valley became the first master-planned city in Orange County. In the years that followed, that plan's foresight has helped Fountain Valley avoid playing "catch up," as so many other communities had to do because of the fantastic growth rate of the 1960s.

On June 13, 2007, Fountain Valley celebrated the 50-year anniversary of its incorporation. The photographs that follow offer a glimpse into Fountain Valley's past.

One

A COMMUNITY
BECOMES A TOWN
PIONEERS AND SETTLERS

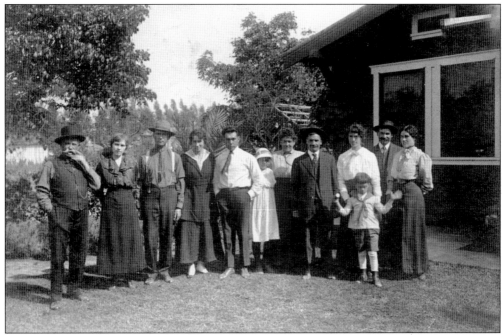

This photograph shows the Courreges family in front of their home. Depicted are, from left to right, Roch Courreges, Elsie ?, Joseph John Courreges Sr., Jessie Courreges, John E. Courreges, Nellie Smith, Magdalena Courreges, Pete Lacabanne, Lizzie Courreges, Henry Landin, and other family members. (Courtesy of Hazel Courreges.)

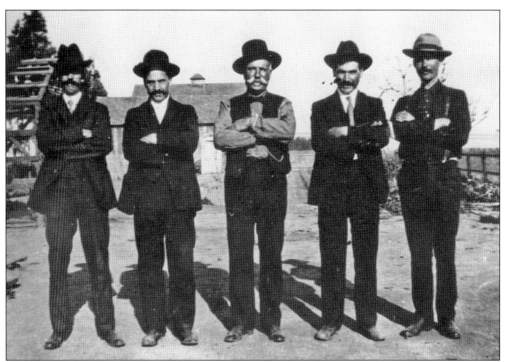

Roch Courreges, recognized for his mustache, poses on his ranch with family members, including the two Lacabanne brothers, both of whom married Courreges's daughters. (Courtesy of City of Fountain Valley.)

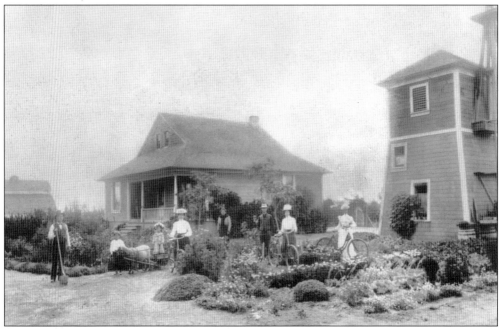

The Courreges Ranch was built about 1909 on the bluff where Talbert Avenue and Newland Street intersect today. Although this house burned down in 1915, it was rebuilt. The house and water tower still stand on this site today. (Courtesy of Hazel Courreges.)

This photograph shows the original handwritten contract to rebuild the Courreges house on top of the existing basement of the burned-down home. (Courtesy of Hazel Courreges.)

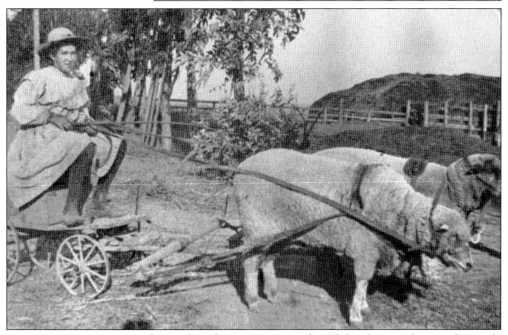

Mary "Marie" Courreges is depicted on the Courreges ranch with her favorite sheep and an early mode of transportation. (Courtesy of Hazel Courreges.)

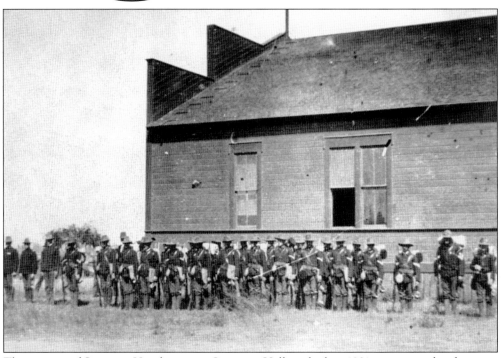

This portrait is of Joe Courreges Sr., who was a member of Company H of the 7th Infantry of the National Guard of California. This new military company was mustered in on November 18, 1900, and was made up mostly of men from the so-called "Peatlands," which were the Huntington Beach–area communities of Smeltzer and Wintersburg. The company was headquartered in Talbert in Sycamore Hall, which had been built on Wardlow family property. The hall later became an armory after the Spanish-American War, which took place in 1898. Company H was mustered out in September 1904 and joined the famed Company L of Santa Ana. (Courtesy of Hazel Courreges.)

This image is of Company H in formation. Sycamore Hall was built in 1901 to serve as a headquarters after the formation of the company. The mustering-in officer was S. H. Finley. (Courtesy of Hazel Courreges.)

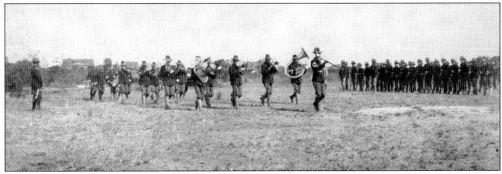

Here Company H stands at attention while the marching band passes by. The company was short-lived in the town of Talbert. By September 19, 1904, the company was officially mustered out, and the personnel were absorbed into Company L, which was organized in 1890 out of Santa Ana. Over the years, Company L was sent to assist in San Francisco after the earthquake of 1906, to Arizona to search for the outlaw Pancho Villa, and to action in the Spanish-American War, World War I, World War II, and the Korean War. This photograph may be of the mustering in or out of Talbert's Company H. (Courtesy of Hazel Courreges.)

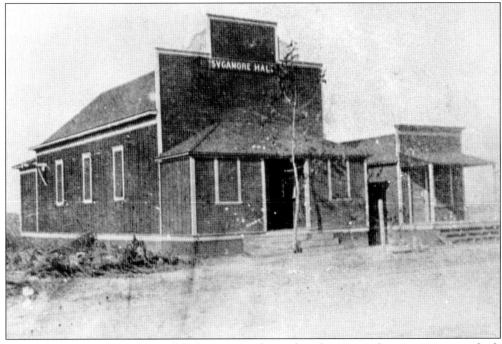

This image shows Sycamore Hall before it was relocated to the Wintersburg community, which is now known as Huntington Beach. The first Fountain Valley Fire Department now occupies this site. (Courtesy of Hazel Courreges.)

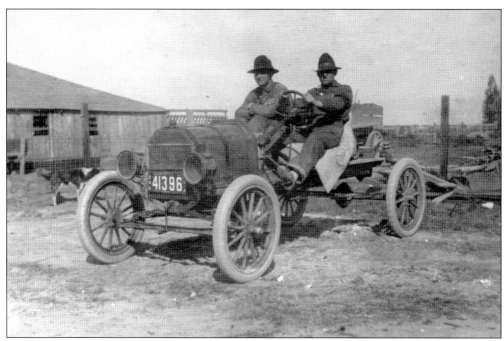

Seen here are two members of the Lamb family in their car. Lamb later became the superintendent for the Stearns Rancho Company. (Courtesy of Earl Lamb.)

These are examples of contracts and deeds that were drawn up during the 1890s between the Lamb family and the Stearns Ranchos, the Pacific Electric Railway, and the Irvine Company. (Courtesy of Earl Lamb.)

This image shows the inside of the Stearns Ranchos contract with the company's embossed seal. (Courtesy of Earl Lamb.)

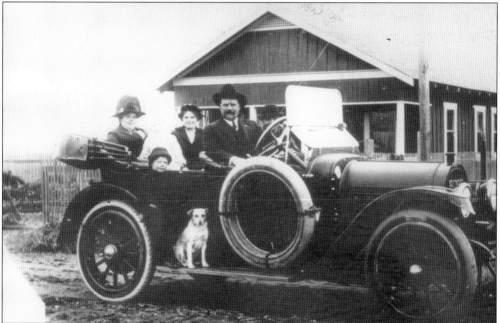

This is the Callens family in their 1912 Pope Hartford automobile in front of their home. The picture shows Rene, Virginie, Uncle Maron, Marie Callens Gisler, Bernice Callens Friedrich, and Joe (on the running board with the family dog, Sport). Rene Callens served as director of the Talbert Drainage District and had farmed the area since 1910. (Courtesy of Callens family.)

This is Robert Bruce Wardlow, who came from Long Beach and settled in Fountain Valley after purchasing 160 acres. (Courtesy of Wardlow family.)

Ray Wardlow is depicted here at two years old. Ray married and had twin boys named Lloyd and Floyd, who continued to farm in the area. (Courtesy of Wardlow family.)

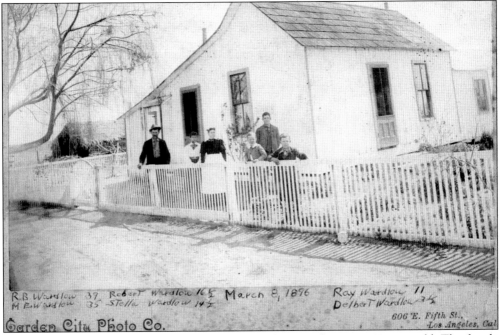

R.B Wardlow 37 Robert Wardlow 16½ March 8, 1896 Ray Wardlow 11
M.E.Wardlow 35 Stella Wardlow 14½ Delbert Wardlow 3½

Garden City Photo Co.

606 E. Fifth St.,
Los Angeles, Cal.

The Wardlow house is seen here in 1896. In this photograph, Ray is 11 years old. The family name still remains on one of the main east-west thoroughfares in Long Beach, Wardlow Road. (Courtesy of Wardlow family.)

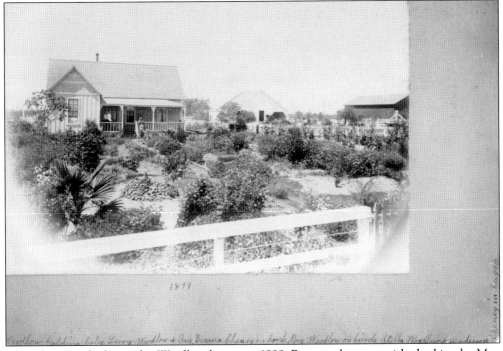

1899

This photograph shows the Wardlow house in 1899. Ray can be seen with the bicycle. Mrs. Wardlow (Ray's mother) is holding baby Leroy. Emma Cheney is on the porch, and to the right are Stella Wardlow and Henderson Cheney in the buggy. (Courtesy of Wardlow family.)

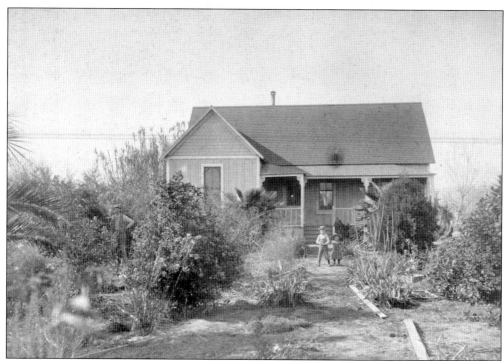

This photograph shows the Wardlow house during the early 1900s. Mr. Wardlow at the far left, and Mrs. Wardlow at the far right. (Courtesy of Wardlow family.)

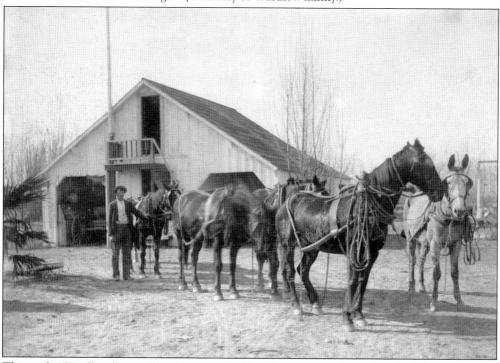

This is the Wardlow barn with a buggy parked inside and a ranch hand with the conveyance's horse team. (Courtesy of Wardlow family.)

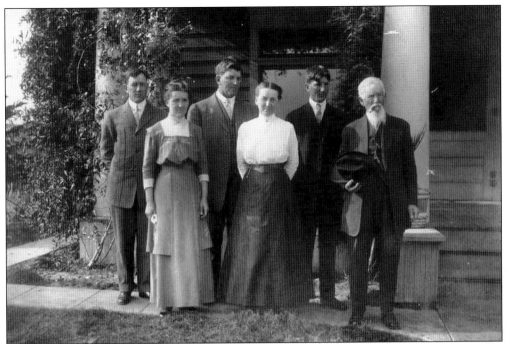

The Talbert family is seen here in 1912. Tom Talbert operated the U.S. post office. He is depicted with, from left to right, Eva, his brother Sam, his sister Mary, his brother Henry, and his father, James T. Talbert, who came from Long Beach to buy the original acreage. (Courtesy of Orange County Archives.)

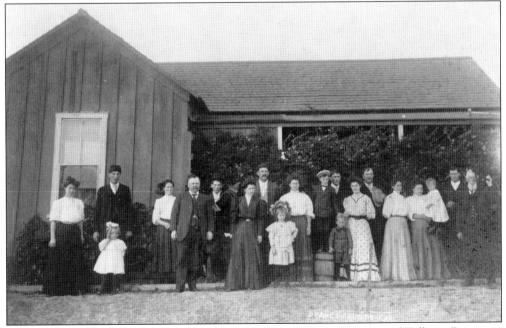

This photograph shows a Talbert family reunion in 1908 in the town of Talbert. Reunions were a common occurrence in those days, fostering family unity. (Courtesy of Orange County Archives.)

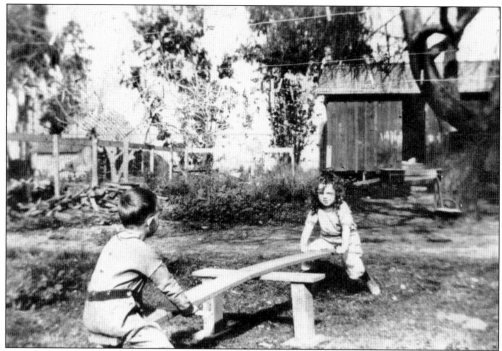

In small farming communities without public parks or recreation facilities, some farms made their own. This 1920s photograph shows a brother and sister playing on a homemade teeter-totter at their home in Fountain Valley. (Courtesy of Fountain Valley Historical Society.)

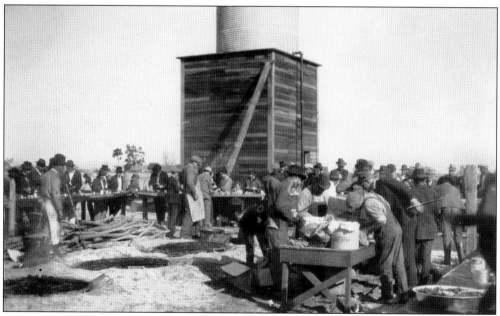

This image depicts one of the early fiestas, which lasted up to three days and included horse races, boxing, music, games, and barbecues. Notice the barbecue pits and the people enjoying their food, as well as the large tub of Bishops Peanut Butter on the right edge of the table. (Courtesy of Orange County Archives.)

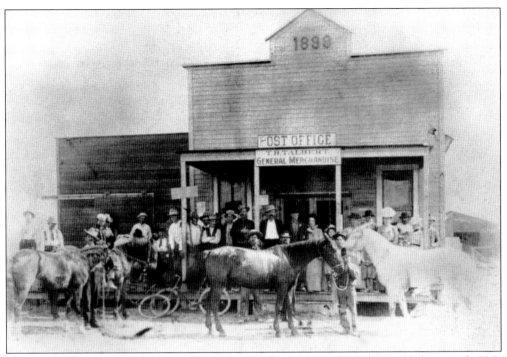

This is the Talbert General Store in 1899, shortly after it was granted the establishment of a U.S. post office. (Courtesy of First American Title.)

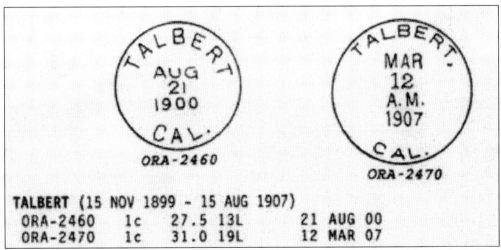

ORA-2460

ORA-2470

TALBERT (15 NOV 1899 - 15 AUG 1907)
ORA-2460	1c	27.5	13L	21 AUG	00
ORA-2470	1c	31.0	19L	12 MAR	07

Two examples of the original cancel stamp for the Talbert Post Office are depicted here. The Talbert postal outpost was discontinued on August 15, 1907, and was absorbed into the expanded Santa Ana Post Office system. Apparently, the Talbert Post Office left very few traces of its existence. (Courtesy of Richard W. Helbock.)

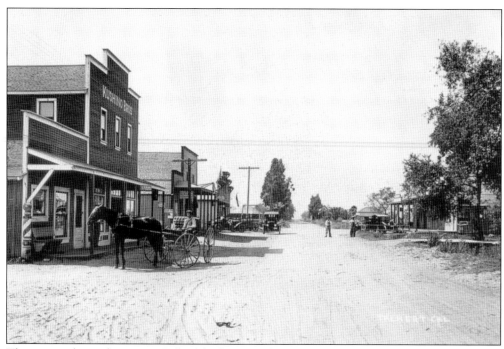

This image shows downtown Talbert looking north on Bushard Street at its intersection with Talbert Avenue. (Courtesy of First American Title.)

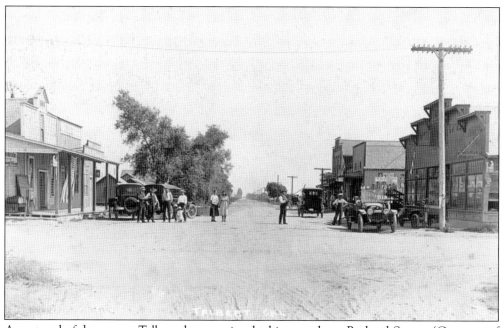

A postcard of downtown Talbert shows a view looking south on Bushard Street. (Courtesy of Hazel Courreges.)

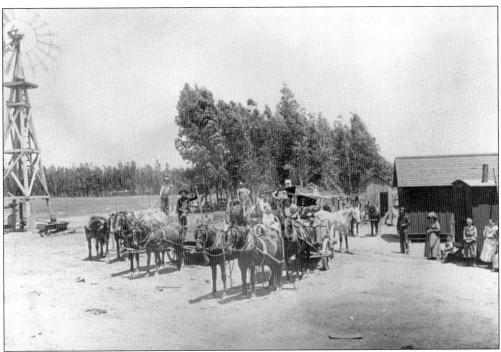

These wagon teams were assembled on a local Fountain Valley farm. (Courtesy of Orange County Archives.)

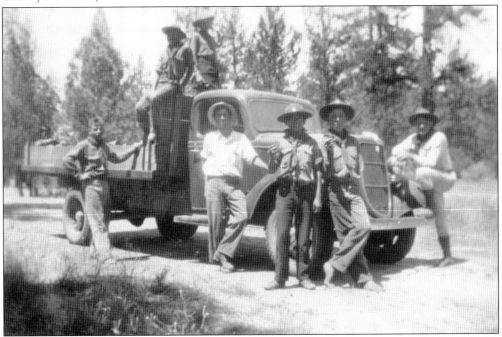

The Talbert Boy Scout troop is shown on a trip to the mountains. Depicted are, from left to right, Lloyd Wardlow, Kato, Shammy, L. Boer, Yoshida, Floyd Wardlow, and troop master Stephen Fitz, who was a teacher. Fitz later had a Garden Grove elementary school named after him. (Courtesy of Louis Betschart.)

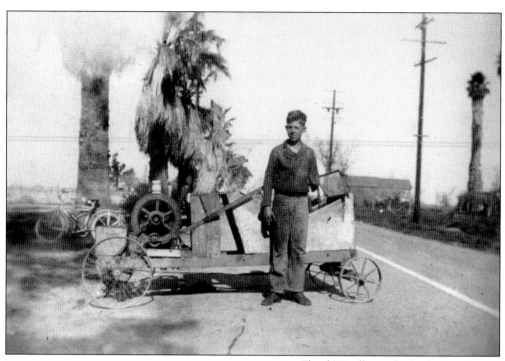

Floyd Wardlow, who had a knack
for mechanics, built this moving
vehicle from scrap. One can see in
this photograph that Floyd had lost
his left arm. He had survived a farm-
equipment accident at a young age.
(Courtesy of Joseph Louis Betschart.)

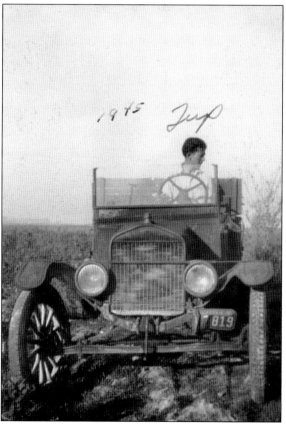

Floyd Wardlow, nicknamed
"Tup," is depicted driving the
family automobile. The license
plate bears the year 1941.
(Courtesy of Wardlow family.)

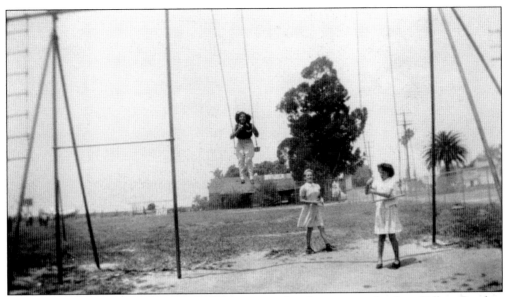

Lillian Garcia and classmates play on the swings at the elementary school on Talbert Road in 1947. This view looks north on Bushard Street, and in the background is the Wardlow property with their planes to the left. This is where the Fountain Valley No. 1 Fire Station sits now. To the top right is Talbert Meat Company, which was started by August Martel in 1907. Years later, it was leased to Joseph Betschart Sr., who continued to operate it as Talbert Meat Company. This site is now Fountain Valley High School. (Courtesy of Lillian Garcia.)

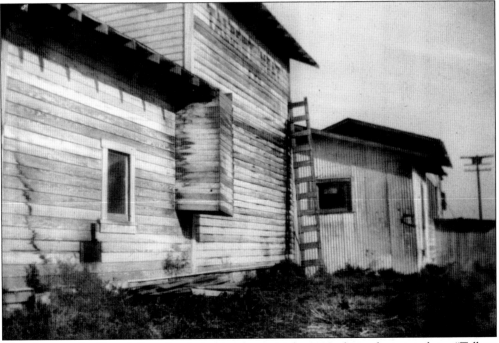

This photograph of Joseph Betschart's slaughterhouse in the 1930s shows the painted sign "Talbert Meat," which dates from 1907 when August Martel first opened the store. (Courtesy of Joseph Louis Betschart.)

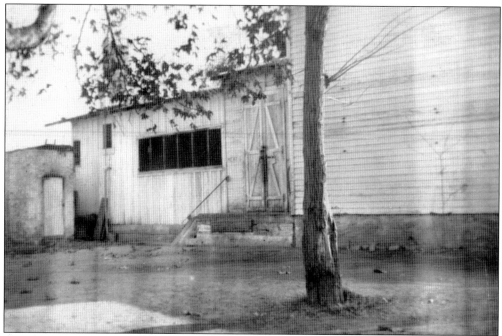

This picture shows the other side of Betschart's slaughterhouse, with the smokehouse visible on the left side. (Courtesy of Joseph Louis Betschart.)

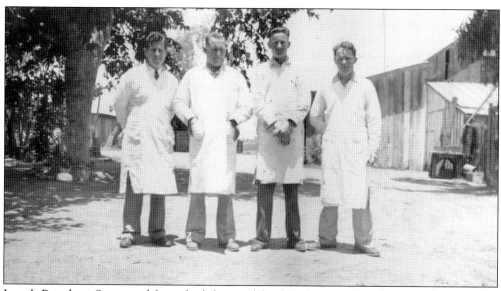

Joseph Betschart Sr., second from the left, posed for this photograph with his employees at the Talbert Meat Company. Betschart operated Talbert Meat until World War II started, at which time he moved out of the town. (Courtesy of Joseph Louis Betschart.)

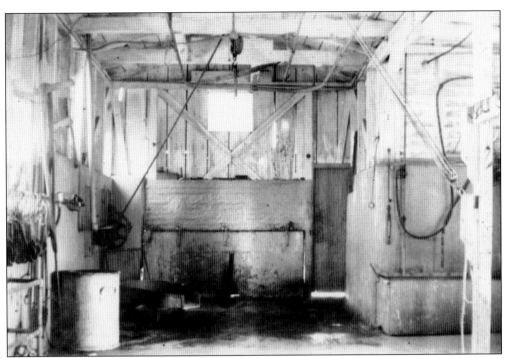

This picture shows the inside of Betschart's slaughterhouse in 1936, the same year that young Louis Betschart graduated high school at age 15. All kids in the area attended Huntington Beach High School because it was the only high school around. Coincidentally, Betschart's slaughterhouse property later became the site of Fountain Valley High School. (Courtesy of Joseph Louis Betschart.)

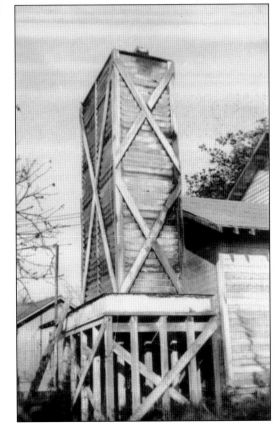

This was the cooling tower that refrigerated the meat for the Betschart slaughterhouse. It ran water over ammonia through a coil system, creating the cold air necessary to refrigerate meat. (Courtesy of Joseph Louis Betschart.)

Depicted here are workmen laying sewage pipes down the center of Bushard Street just south of Talbert Avenue and in front of the Talbert Café. At one point, the famous Red Cars of the Pacific Electric Railway ran up and down Bushard Street. The structure on the far right was the original blacksmith shop location, which later became this welding shop. (Courtesy of Nellie Calderon and family.)

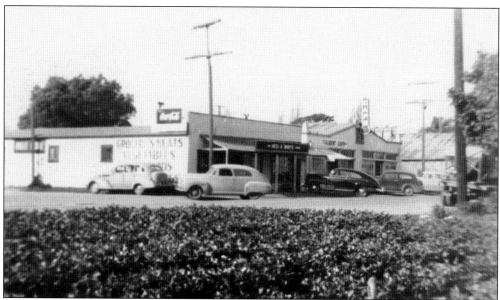

Taken from the Calderon property, this image shows the Talbert Café and the Red and White storefront during the 1930s. The Red and Whites were a chain of general merchandise stores in the United States and Canada. (Courtesy of Nellie Calderon and family.)

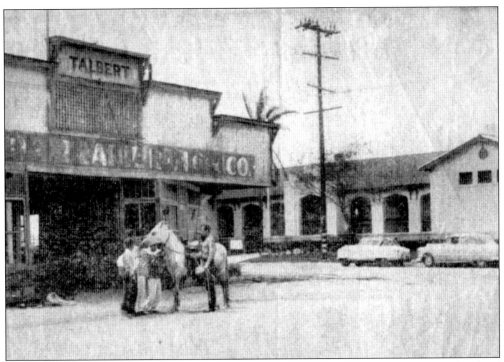

This was the only picture available showing the front of the blacksmith shop at the corner of Bushard Street and Talbert Avenue. It later became a welding business. (Courtesy of Hazel Courreges.)

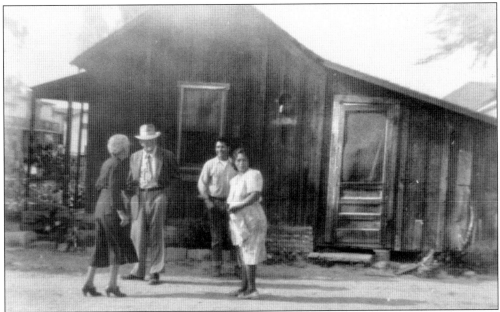

Pictured here at the Calderon home are, from left to right, Hattie and Sam Talbert and Tony Calderon and his mother, Lucy. Their home sits on the east side of Bushard Street, across and down the street from the Talbert Café. The home has since been replaced with another, and the Calderon family still lives there today. Sam and Hattie lived across the street. (Courtesy of Nellie Calderon and family.)

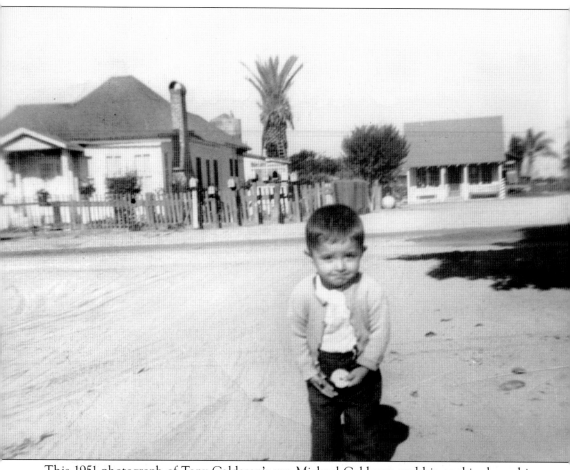

This 1951 photograph of Tony Calderon's son Michael Calderon and his cookie shows him in the driveway of the Calderon property, with Sam Talbert's home and the local barbershop in the background. Years later, the Odas moved to the Talbert home and ran the barbershop. Note the barbershop pole in front of the structure on the right. (Courtesy of Nellie Calderon and family.)

Two

TAMING THE WATER, FARMING THE LAND

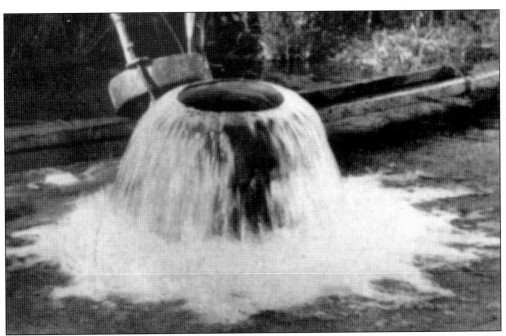

This image depicts a tapped well. They were very common in the area. Tom Talbert used this photograph on his business letterhead. He moved his business to Huntington Beach in 1904 to take advantage of the arrival of the Pacific Electric Railway's Red Cars, which brought thousands of people and potential customers to that city. One story of how Fountain Valley got its name was told to Jim Kanno, the first mayor of Fountain Valley, by members of the Wardlow family. According to that version, irrigating farmers trying to dilute the high concentration of alkali in the area would sometimes bend nearby reeds over the tops of the flowing water, creating a spray, or fountain, appearance. (Courtesy of First American Title.)

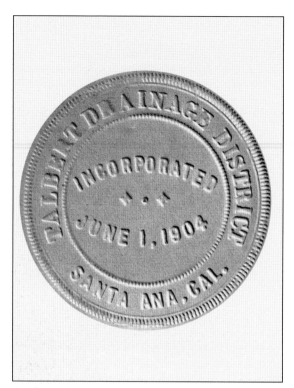

This is the seal of the Talbert Drainage District, which was formed in 1904. Because the area flooded almost every spring, the district was organized. Spearheaded by Sam Talbert, the creation of the district required a $24,000 bond issue to protect 15,000 acres. The issue was voted on by residents, and it passed. Ditches 15 feet deep were cut on the east side of each main road from north to south. The excavated dirt was piled to form a levy and a roadbed. Sam Talbert was known to do most of the digging himself. Next, the Santa Ana River had to be contained, so the Newbert Protection District, covering 18,000 acres, was organized. Again, Sam Talbert was one of the leaders in this effort. "Newbert" was derived from combining the names of Newport Beach and Talbert, two of the communities most affected by the floods. (Courtesy of Orange County Archives.)

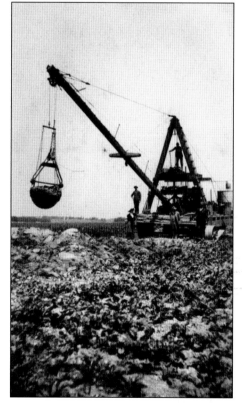

This is the first channel dug by Talbert Drainage District, just below the Gisler family property near Atlanta and Cannery Streets (Cannery was later renamed Magnolia), using a clam dragline. The Gislers, a Swiss family, came to the area in 1903 and started a dairy herd. By 1919, the Gislers owned more than 300 acres, which were farmed once the land was drained. (Courtesy of Orange County Archives.)

The dirt that was pulled from the canals was used to form road berms. (Courtesy of Orange County Archives.)

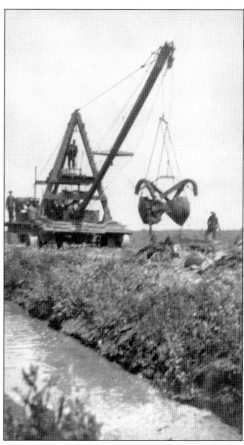

This photograph shows a view from the clam dragline operator's perspective. (Courtesy of Orange County Archives.)

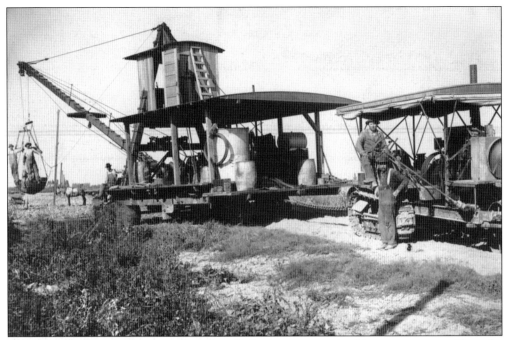

The heavy dredgers had to be pulled along by horse teams, or in this case, a tractor. Note the horse and buggy in the background. (Courtesy of Orange County Archives.)

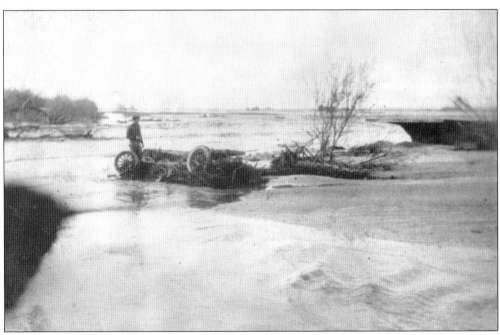

This man is standing by the overturned wreckage of his automobile after the flood of 1916. This flood overwhelmed the systems that the Talbert and Newbert Drainage Districts had set up prior to the rains. It became clear that a dam was necessary to control future floodwaters. (Courtesy of Fountain Valley Historical Society.)

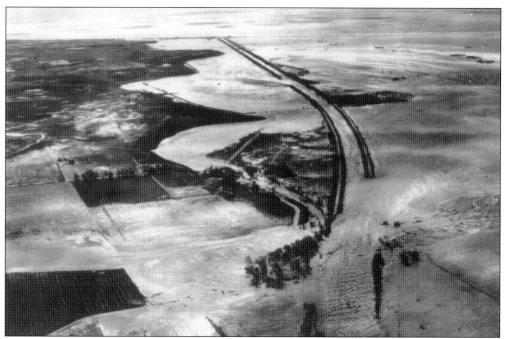

Seen here is an aerial view of the 1938 floodwaters breaking through the levees. Orange County's new sewer-outfall facility in Fountain Valley was practically washed away and allowed untreated sewage to run down the Santa Ana River. (Courtesy of First American Title.)

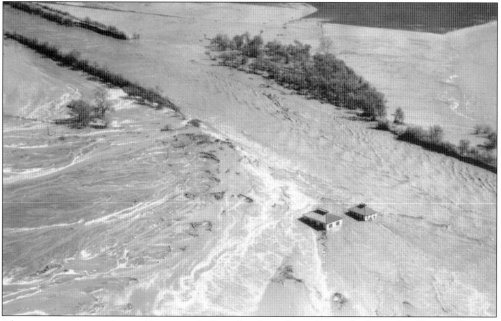

The two structures pictured here are believed to have been located where the Orange County Water District now operates, near Euclid and Ellis Streets. In 1933, the California legislature created the Orange County Water District, but it was not until 1941 that Prado Dam was built solely as a flood-control facility. The dam is located about two miles above the Orange County line in Riverside County, just west of Corona. (Courtesy of First American Title.)

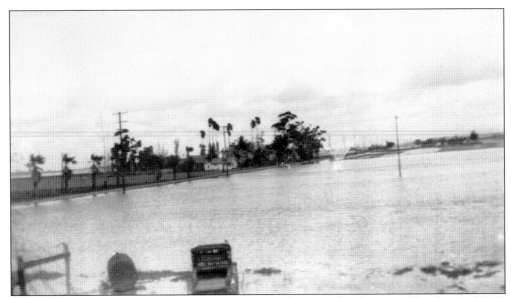

This image looks from the Betschart property north on Bushard Street. The flood of 1938 completely covered the low-lying areas of Fountain Valley. Even during normal seasons, some of these low-lying areas would not dry out, and locals would call them lakes by the names of whose property they were on. (Courtesy of Joseph Louis Betschart.)

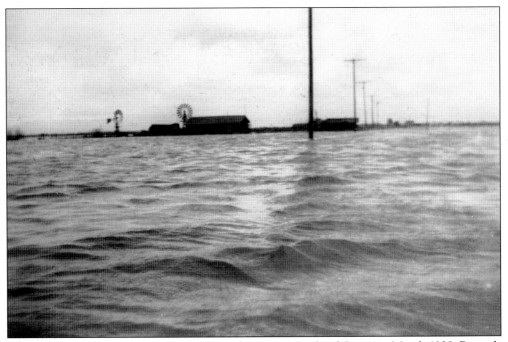

This was the scene looking south of Talbert Avenue on Bushard Street in March 1938. Records indicate that at least 22 inches of rain fell in the local mountains, pushing 100,000 cubic feet of water per second—or over 43 million gallons per minute—down the river. The pressure broke levees and twisted railroad tracks. The flood lake fanned out all across Orange County. At least 45 people were killed. (Courtesy of Joseph Louis Betschart.)

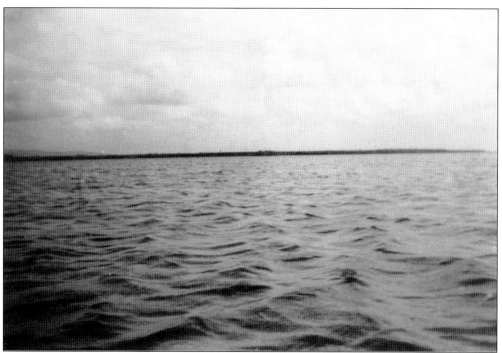

This is the field behind the slaughterhouse. Local papers reported that hundreds of overturned cars and homes were carried down the streets throughout the county. Parts of Pacific Coast Highway were washed out to sea, and pigs and chickens from Fountain Valley farms ended up on the beaches. (Courtesy of Joseph Louis Betschart.)

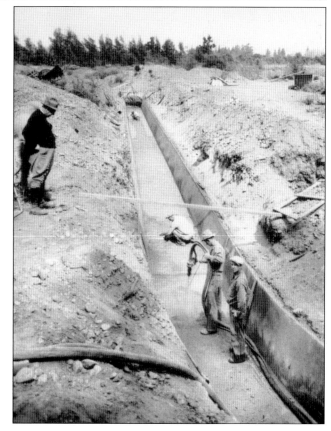

These workers are laying the cement base for the control channels. These control channels were a vital part of the Orange County Water District's efforts to keep the farmland from flooding. The man on the left appears to be overseeing the operation. (Courtesy of First American Title.)

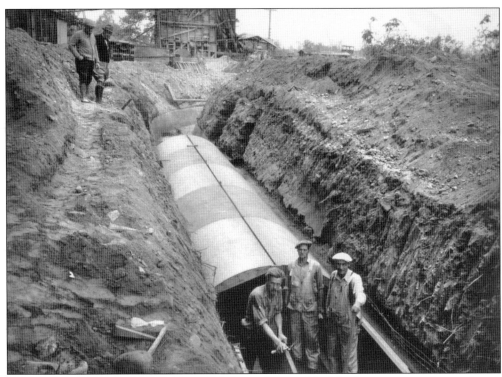

Here the progression of the flood-control channels is visible. The levee tops are being placed. (Courtesy of First American Title.)

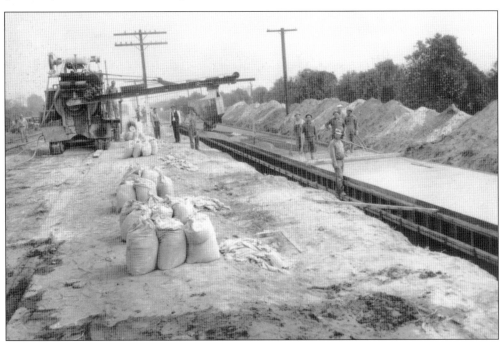

These workers are filling the cement forms for the Santa Ana River flood control channel. (Courtesy of First American Title.)

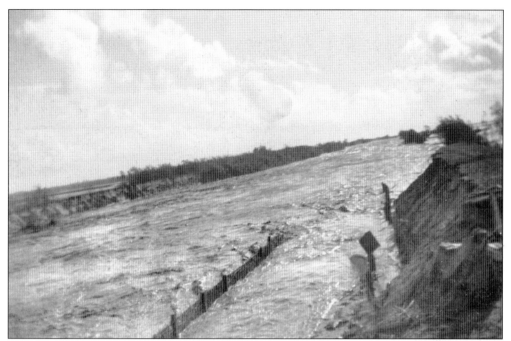

Taken at Talbert Avenue days after the 1938 flood, this photograph shows the Santa Ana River flowing at full capacity toward the Pacific Ocean. (Courtesy of Joseph Louis Betschart.)

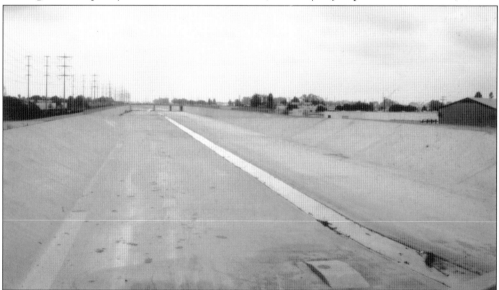

Seen here is the Santa Ana River bed in a present-day shot from the Talbert Avenue Bridge. This is where a train trestle used to cross the river. Fully cemented, this area of the river is not used by the Orange County Water District as a percolation basin and therefore has less silt buildup and remains clean and clear. On either side of this bridge stood two concrete-mixing stations. During the rainy seasons, the mixing station used depended on which side of the river one was on. The station on the west side still exists today. The other location is now an Orange County Transportation District building. Here the span of the river is considerably larger than the one in the previous photograph. (Courtesy of Laura Hollander Gibb.)

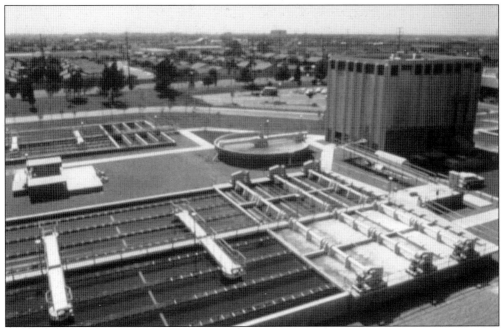

This structure is Orange County Water District's now famous Factory No. 21, which is on Euclid and Ellis Streets. By 1956, years of heavy pumping to sustain the region's heavy agricultural economy had lowered the water table below sea level, and saltwater from the Pacific Ocean had encroached as far as five miles inland. Primarily in an area known as the Talbert Gap, this factory would blend reclaimed water and inject it into the groundwater to form a barrier to stop further seawater intrusion. (Courtesy of Orange County Water District.)

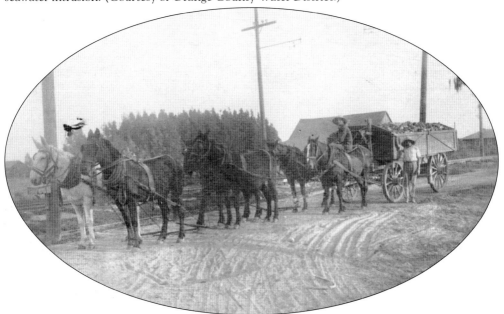

This early photograph shows a six-horse wagon team on its way to the sugar beet dumps near Bushard and Garfield Streets, where the vegetables were loaded onto train cars. Some farmers would deliver their harvest directly to the sugar companies. (Courtesy of Earl Lamb.)

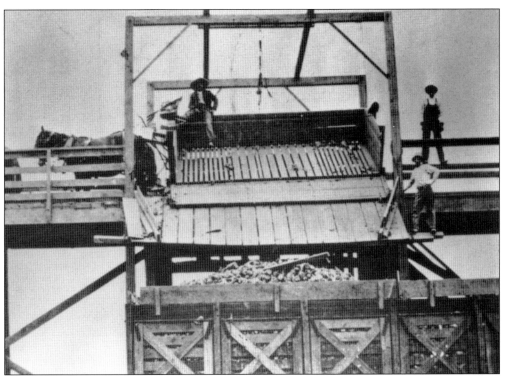

Here horse-drawn wagons dump their sugar beets into the train cars. (Courtesy of First American Title.)

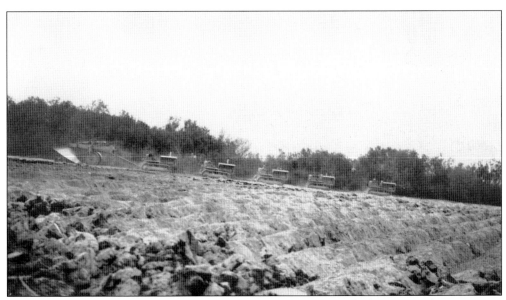

This field is being turned over by the Post Brothers' 6-foot plow, which was rented to numerous farmers in the area. This plow now sits at Brookhust Street and Bolsa Avenue, commemorating the valley's rich farming heritage on a historical site. (Courtesy of Earl Lamb.)

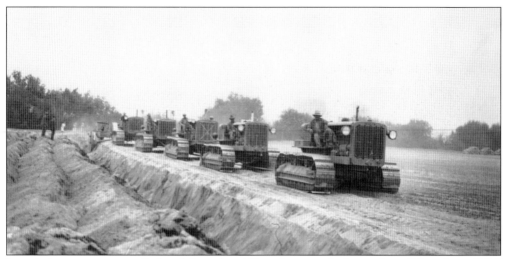

It took five tractors to pull this 6-foot plow. This photograph shows three D8 and two RD7 Caterpillar tractors pulling the plow to turn over the soil on the Gisler ranch. The 1933 Long Beach earthquake brought sand percolating to the surface in Orange County's coastal areas. And the 1938 Santa Ana River flood brought as much as two feet of silt to cover up topsoil. So, farmers needed much more than simple tilling. These massive plows literally helped keep farmers in business. (Courtesy of Earl Lamb.)

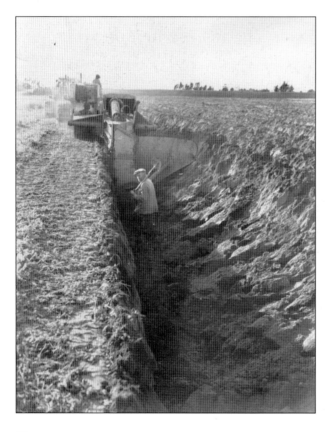

Walking behind the operation, this farm worker is in the cut left by the Post Brothers' regionally famous 6-foot plow. (Courtesy of Orange County Archives.)

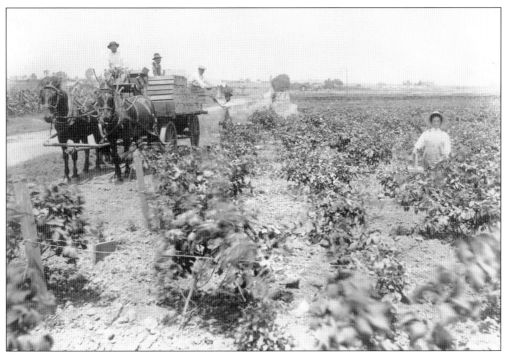

This Kanno family photograph shows workers loading crates onto horse-drawn wagons. In the foreground, a woman works the fields. (Courtesy of Jim Kanno.)

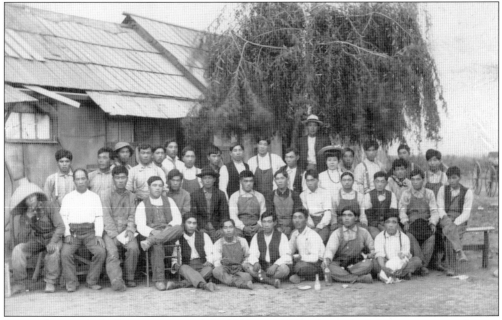

As was done with the bracero camps of the 1940s and 1950s, from which Mexican nationals were recruited by U.S. concerns to work in the states, Japanese immigrants, mostly single men who had just arrived in America in the 1920s and 1930s, looked for work out of base camps. Some lived in barracks-style camps, while others stayed with families. Note the pets in the front row on the right. (Courtesy of Jim Kanno.)

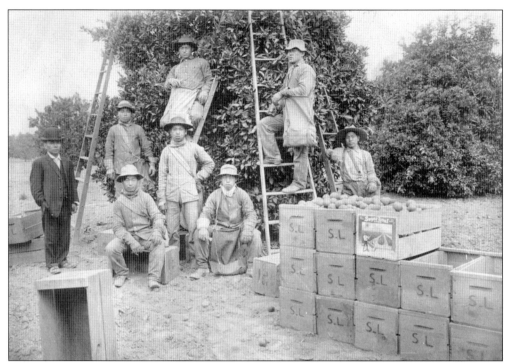

With the foreman standing nearby, these workers stopped to pose for this photograph. Note the crates are labeled "Sugar Loaf Company." (Courtesy of Jim Kanno.)

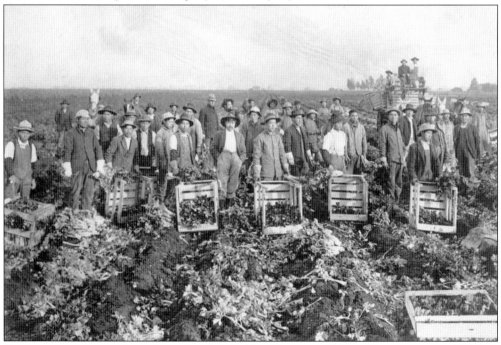

Here is a typical scene from the early celery fields of Fountain Valley. The wagons would follow behind the workers so they could load the crates as they went along. The tall Caucasian man standing in the back is unidentified. (Courtesy of Jim Kanno.)

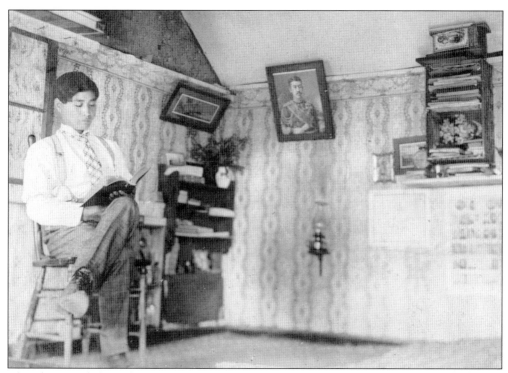

This photograph from the Kanno family is an example of the inside living spaces of the Japanese community. The man sitting here is unidentified. Note the kerosene lamp in the center, attached to the wall. (Courtesy of Jim Kanno.)

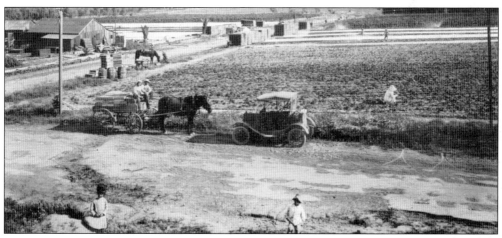

Seen here are both primary forms of transportation used in the early 20th century, before the area substantially switched from field-crop farming—in which the harvests were hauled in wagons—to truck farming. The children in the foreground are shown at play, while their mother works in the fields. (Courtesy of Jim Kanno.)

Kyutaro Ishii is depicted here standing between the horses of his team. Note the cars in garage behind him. This photograph was taken in 1931. (Courtesy of Mrs. Charles Ishii.)

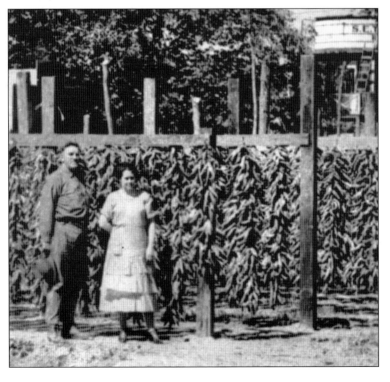

A proud couple poses with their chili pepper crop, ready for harvest. A water tower can be seen in the background. (Courtesy of Orange County Archives.)

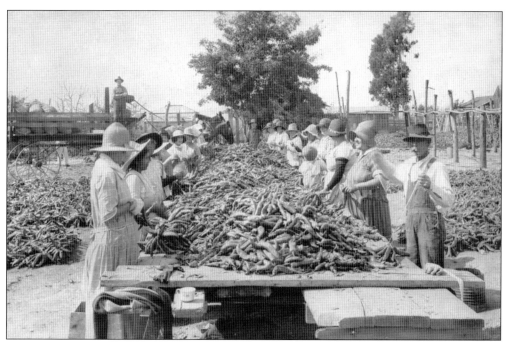

A group of workers sort through the chili pepper crop, preparing the harvest to be loaded and sent to market. Chili peppers were a huge industry for the area. Some said that Fountain Valley at one time was the chili pepper capital of the county. Long before day care centers were available, small children were an everyday presence at harvest time. (Courtesy of Orange County Archives.)

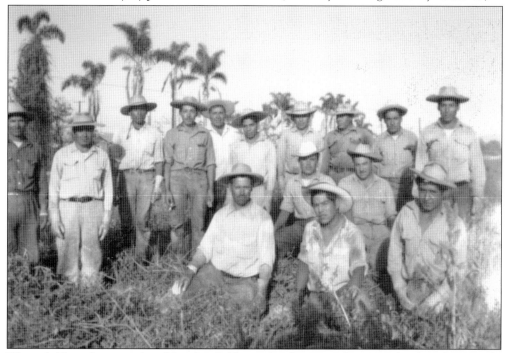

These field workers, employed by the Calderon family, stopped to pose for this photograph. (Courtesy of Nellie Calderon and family.)

Driving through Fountain Valley in the 1940s and 1950s typically provided the kind of roadside scenery pictured here. The fields would often have stacks of crates and nothing but wide-open spaces beyond. (Courtesy of Wardlow family.)

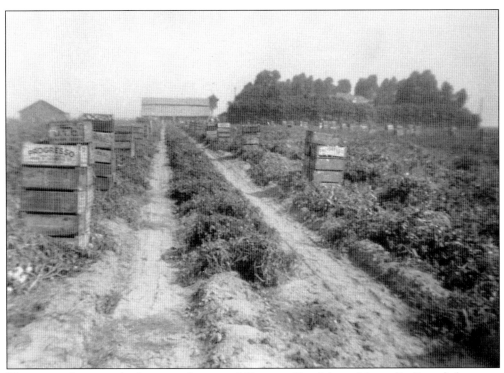

Here is another view looking north, west of Cannery Road (now Magnolia Street), between Talbert and Slater Avenues. (Courtesy of Fountain Valley Historical Society.)

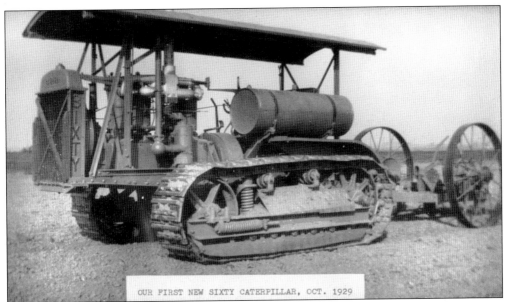

OUR FIRST NEW SIXTY CATERPILLAR, OCT. 1929

This was the Callens family's first new Sixty Caterpillar, shown here in October 1929. In 1910, Rene and Virginia Callens arrived and bought 60 farming acres in Fountain Valley. By 1936, they were up to 1,400 acres, 180 of which were in Fountain Valley. Rene served for many years as director of the Talbert Drainage District. (Courtesy of Callens family.)

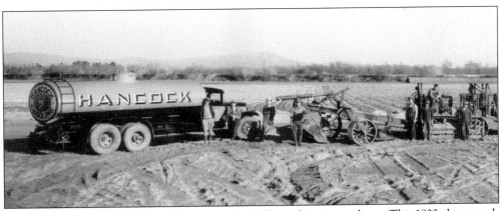

Sometimes refueling tankers would go out in the fields, as this picture shows. This 1932 photograph of a 4-foot plow on the Gisler ranch also shows, from left to right, Johnny Allen, Roy Langley, Johnny Gibson, Paul Plavan, Charlie Atkins, Ervin Titus, Robert Gisler, and Robert's son Tom. Plavan built this plow. His brother, Urban H. Plavan, had a Fountain Valley school named after him. Saddleback Mountain can be seen in the background. (Courtesy of Callens family.)

49

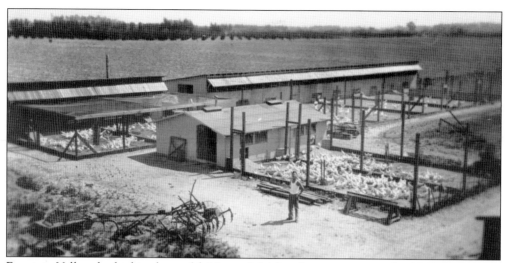

Fountain Valley also had its share of dairies and chicken farms, as seen in this 1935 photograph. (Courtesy of Mrs. Charles Ishii.)

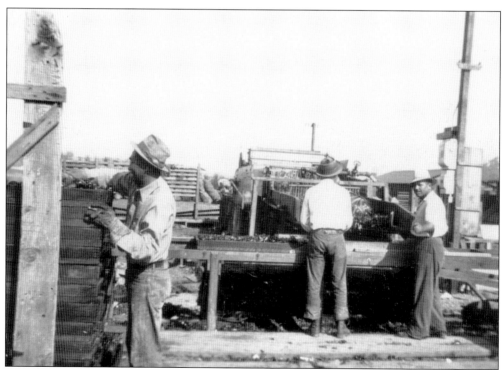

The machine in this picture washed and separated peppers on the Ishii farm. (Courtesy of Mrs. Charles Ishii.)

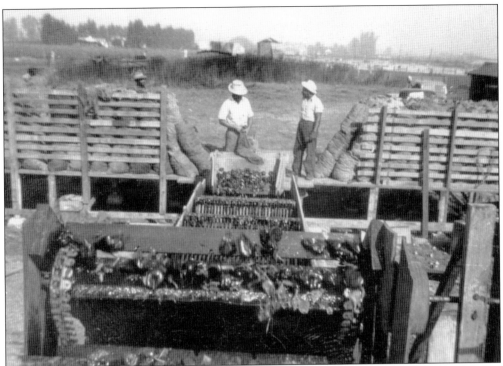

This image also shows the peppers on the Ishii farm being processed for delivery. (Courtesy of Mrs. Charles Ishii.)

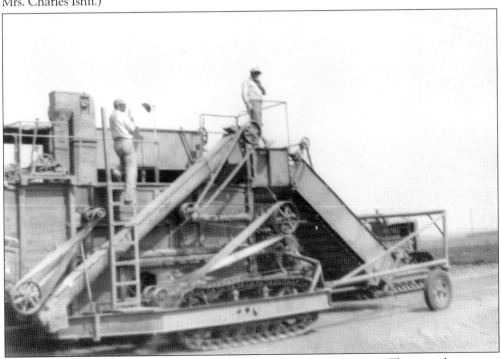

Hugo Lamb's bean-thresher machine is seen here on the Lamb property. These machines were a common sight in Fountain Valley. (Courtesy of Earl Lamb.)

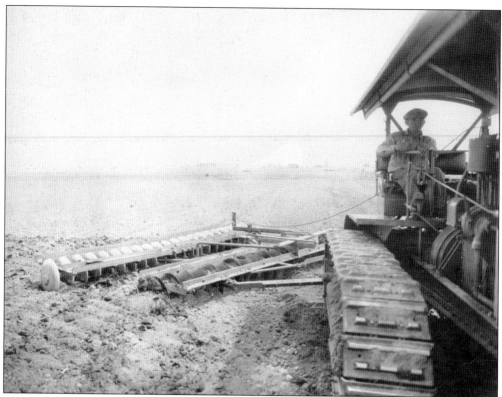

A ranch hand on one of the big, open fields located on the Lamb farm is seen here pulling a disc tiller to prepare the soil for planting crops. (Courtesy of Earl Lamb.)

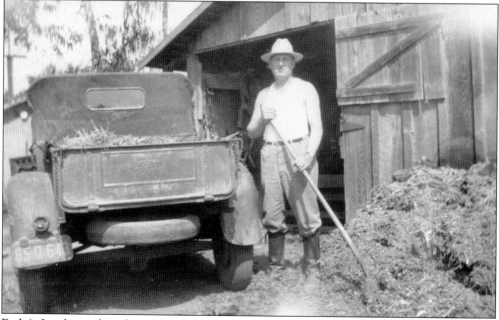

Earl A. Lamb stands in front of his barn, loading his truck. The date of this picture is unknown, but the license plate reads 1942. (Courtesy of Earl Lamb.)

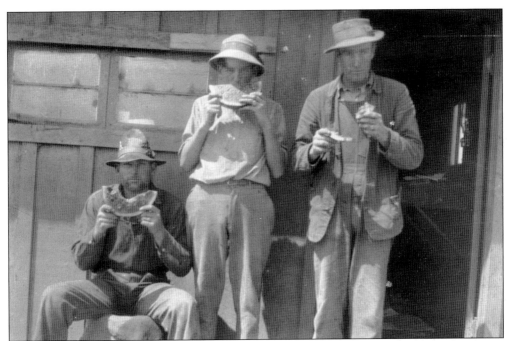

The Lamb farmhands take a break and enjoy some fresh watermelon in this vintage farming shot. (Courtesy of Earl Lamb.)

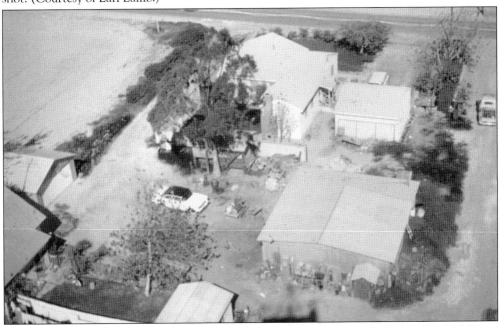

One of the Lamb family homes near Garfield Street is seen here in an aerial view. Garfield Street became the border for Huntington Beach and Fountain Valley. A few families in this area were part of the Fountain Valley incorporation plans, but they chose to petition to be annexed to Huntington Beach. The Fountain Valley School District overlapped this border. Oil wells pumped on the Lamb family property, but most of the prospective wells that were dug on the edges of Fountain Valley only produced water. (Courtesy of Earl Lamb.)

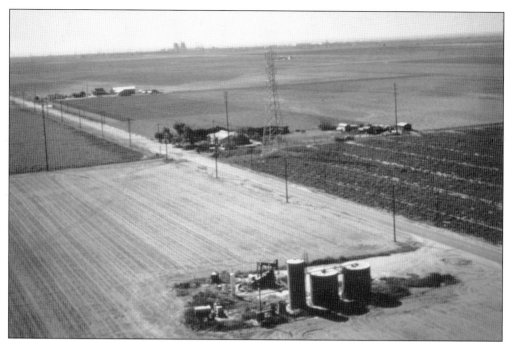

This aerial shot looks south toward the ocean from the Lamb property. It shows another family home, and the Edison Power Plant can be seen in the background at the corner of Newland Avenue and Pacific Coast Highway in Huntington Beach. (Courtesy of Earl Lamb.)

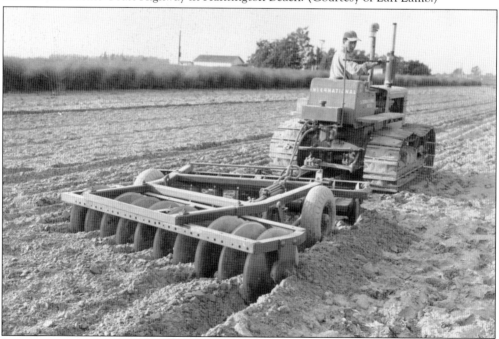

Jim Kanno is shown pulling a disc tiller in 1955. Two years later, he would become the city and county's first mayor of Japanese descent. The encroaching homes and tall asparagus can be seen in the background. As property values increased, the gap between housing tracts and farmland shrunk. (Courtesy of Jim Kanno.)

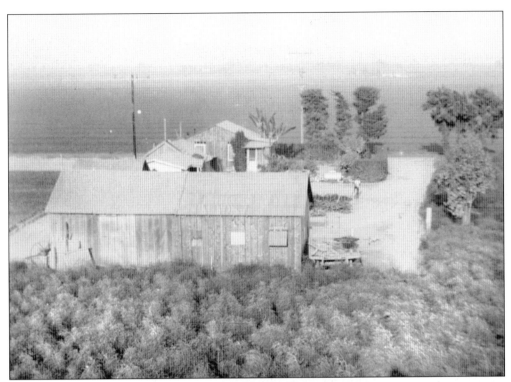

This is the farm of Shuji Kanno in 1946, near Mile Square on Ward Street. A young Jim Kanno, the son of Shuji and the future first mayor of Fountain Valley, can be seen standing in the driveway. The tall asparagus are visible in the foreground. Later the television series *Route 66* filmed a segment on this farm. (Courtesy of Jim Kanno.)

The Kato family built a Quonset hut and used it to store fertilizer and farm equipment. These World War II–era structures were sold to the public as surplus. A Quonset hut is a lightweight, prefabricated structure of corrugated steel. (Courtesy of Taikichi Kato family.)

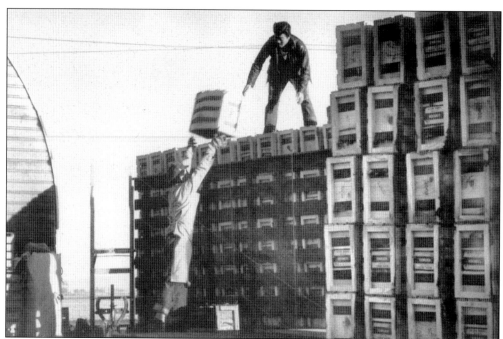

Here a truck is backed up to the Kato family Quonset hut to be loaded with produce. This picture is not dated, but judging by the hairstyle, leather jacket, and blue jeans, it would appear to be the 1950s. This Quonset hut is located on Bushard Street south of Talbert Avenue and still stands today. In the background of this photograph is the intersection of Brookhurst and Talbert Streets. (Courtesy of Taikichi Kato family.)

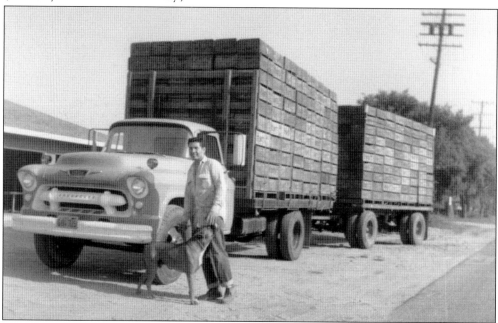

Tony Calderon is seen here in 1957 with his dog Kim in front of his house on Bushard Street, just north of the Kato Quonset hut. He is getting ready to deliver a truckload of tomatoes to Hunt's Foods. (Courtesy of Nellie Calderon and family.)

56

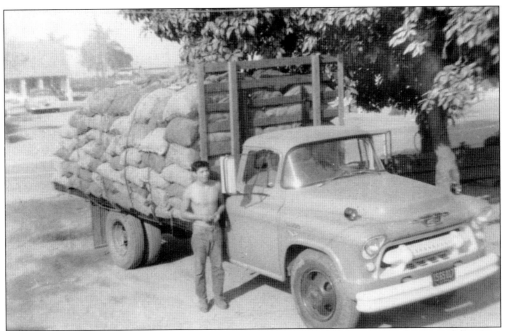

Here is Tony Calderon with a load of chili peppers in front of his home. In the background is Sam Talbert's home on the west side of Bushard Street; the Oda Barbershop is next door. (Courtesy of Nellie Calderon and family.)

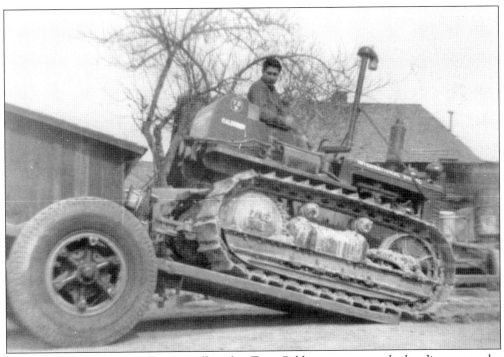

Loading a tractor up onto the carry-all trailer, Tony Calderon appears to be heading out to the fields in 1952. (Courtesy of Nellie Calderon and family.)

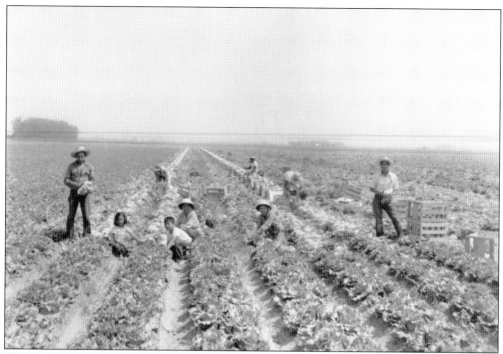

This is Mas Masuda's farm on Warner Avenue about 1957, close to the time that Fountain Valley was incorporated. The farm was located just east of where Plavan Elementary School is today. The two children in this lettuce field are Dennis Masuda, who grew up to become a teacher at Marina High School in Huntington Beach, and his sister Diane. They attended Fountain Valley Elementary School. Behind them is their Aunt Liliy Masuda, Mas's wife. On either side are braceros. (Courtesy of Mas Masuda.)

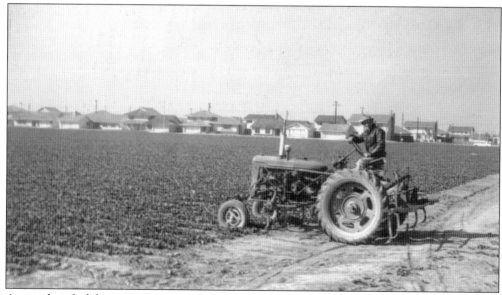

An unidentified farmer pauses to smile for the camera some time in the 1960s. He is depicted working this spinach field near the Treasure Cove housing tract in Fountain Valley. (Courtesy of City of Fountain Valley.)

Three

THE TOWN
BECOMES A CITY
THE MASTER PLAN

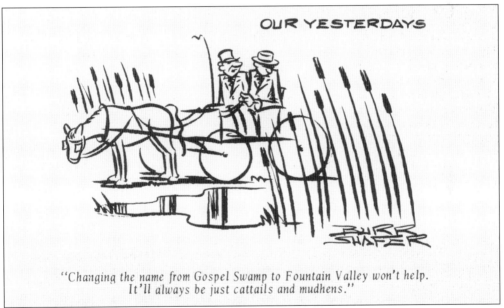

OUR YESTERDAYS

*"Changing the name from Gospel Swamp to Fountain Valley won't help.
It'll always be just cattails and mudhens."*

This cartoon appeared in *Orange County Illustrated* in 1964. The artist, Burr Shafer, was born in 1899 and died in 1965 in the city of Orange, California. His creation unintentionally shows the confusion surrounding the naming of the city. The term "Gospel Swamp" refers to a much larger area of the Greater Santa Ana Valley, stretching from near Bolsa Avenue in the north down into Huntington Beach in the south and from the Costa Mesa bluffs on the east to the bluffs of Huntington Beach on the west. Gospel Swamp describes both the terrain and the numerous itinerant preachers that would hold tent revivals in the area. The Fountain Valley School District was established in 1876. The name only changed in 1899, when the locals applied for a post office, and the name Fountain Valley was denied, and again in 1957, when the town incorporated. Fountain Valley, the last area of the lower Santa Ana Valley to be developed, got stuck with the moniker "Gospel Swamp." (Courtesy of Orange County Archives.)

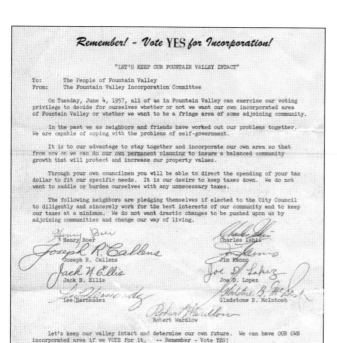

This 1956 flyer put out by the incorporation committee was part of the effort to gather support for cityhood. The existence of the committee first headed by Tim Talbert and later by Robert Wardlow caused the cities of Garden Grove and Santa Ana to expedite their efforts to annex thousands of acres of the town of Talbert. (Courtesy of Hazel Courreges.)

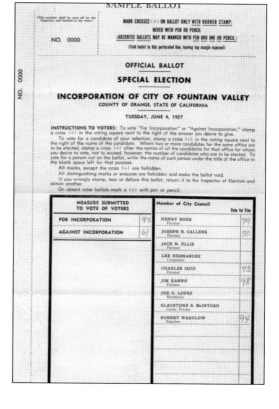

This a sample ballot from 1956. It was quite clear that the aim of the first city fathers was to protect themselves and their properties from the surrounding cities. Their intentions were to keep Fountain Valley predominantly a farming community. The area had 189 registered voters, and 160 of them cast a ballot: 91 voted for incorporation, and 63 voted against it. (Courtesy of Hazel Courreges.)

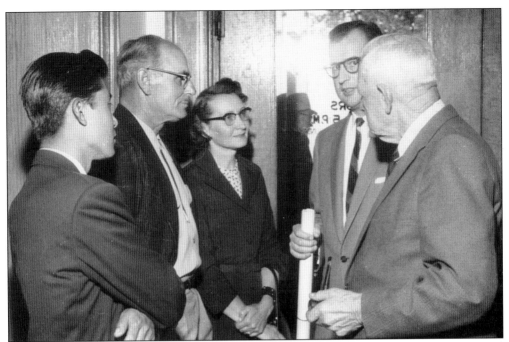

Shown at the Santa Ana Courthouse filing incorporation papers are, from left to right, Jim Kanno, Ed and Elsa Hoffman, Harmon Scofield, and Robert Wardlow. The resolution from the Orange County Board of Supervisors that was sent to the office of the California Secretary of State was received and filed on June 13, 1957, meaning that the city of Fountain Valley was incorporated as a general-law city and as the 21st city in the County of Orange. Kanno was soon elected the first mayor, and Ed Hoffman was sworn in as the first Fountain Valley police chief. (Courtesy of Jim Kanno.)

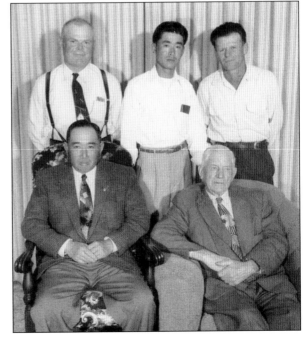

The first Fountain Valley City Council is depicted, from left to right, as follows: (first row) Charles Ishii and Robert Wardlow; (second row) Joseph R. Callens, Jim Kanno, and Henry Boer. Each man was listed on the ballot as a farmer, except for Robert Wardlow. He was listed as a rancher. (Courtesy of Jim Kanno.)

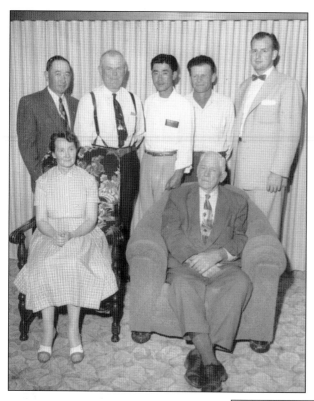

The first meeting of the Fountain Valley City Council was held at the home of Ed and Elsa Hoffman on Slater Avenue, with Elsa as council secretary. Seen here, from left to right, are the following: (front row) Elsa Hoffman and Robert Wardlow, who was elected vice mayor; (second row) Charles Ishii, Joseph R. Callens, Mayor Jim Kanno, Henry Boer, and Harmon Scofield, city attorney. (Courtesy of Jim Kanno.)

At an unidentified street corner, this newspaper photograph shows the newly installed 31-year-old Fountain Valley mayor Jim Kanno and the city's first administrator, 29-year-old F. J. "Bud" Klecker. Note the population and elevation of the city. Jim Kanno was not only the first mayor of the city, but also the first mayor of Japanese descent in the United States. This was before statehood for Alaska and Hawaii. His election was noted across the country and even covered as a news event in Japan. The U.S. government asked Jim to speak on "Voices of America" radio in 1957. VOA radio first went on air in 1942 as a multimedia international broadcasting service. Funded by the U.S. government, it reached millions of people each week with news, information, and education. (Courtesy of Jim Kanno.)

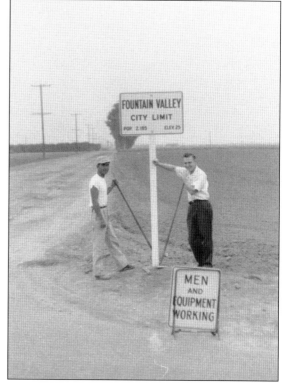

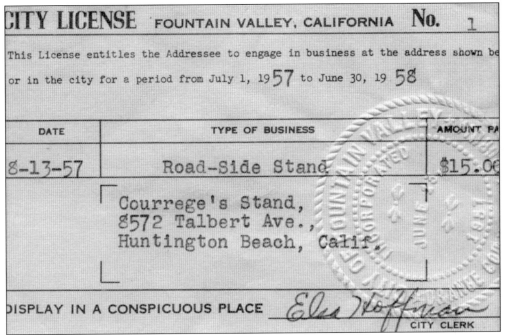

CITY LICENSE FOUNTAIN VALLEY, CALIFORNIA No. 1

This License entitles the Addressee to engage in business at the address shown be
or in the city for a period from July 1, 1957 to June 30, 1958

DATE	TYPE OF BUSINESS	AMOUNT PA
8-13-57	Road-Side Stand	$15.00

Courrege's Stand,
8572 Talbert Ave.,
Huntington Beach, Calif.

DISPLAY IN A CONSPICUOUS PLACE _____ Ela Hoffman

CITY CLERK

This is a copy of the first Fountain Valley Business license. It was issued to Joe and Hazel Courreges. Joe was the grandson of pioneer Roch Courreges. (Courtesy of Hazel Courreges.)

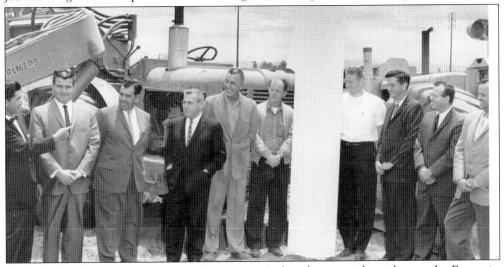

Planning for the coming transition from an agricultural to a residential area, the Fountain Valley City Council commissioned a firm in Santa Ana to develop a master plan for the orderly development of Fountain Valley. No tract development was allowed by any firm until all elements of the master plan were adopted. This is the groundbreaking ceremony on Thursday, June 14, 1962, at 1:00 p.m. for the city's first sanctioned housing tract, called "Westmont." It was built by George M. Holstein and Sons Company. Pictured from left to right are Mayor Jim Kanno; councilman Fred Miola; Joe Courreges, planning commissioner; Rueben Dobkins, purchasing agent; councilman Don Wardlow; city engineering-department employees Ralph Ramsey and Jim Busher; Stan Mansfield, planning director; Ed McDonald, city administrator; and Tom Shelton, city engineer. Note the large "Number One." (Courtesy of Jim Kanno.)

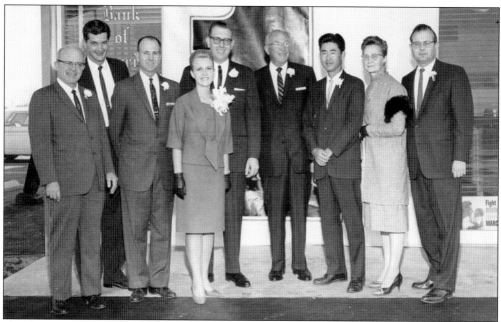

The opening of the first bank in Fountain Valley drew these various bank and city officials. Included in this photograph taken on Brookhurst Street are Mayor Jim Kanno; Elsa Hoffman; and Ed McDonald, city administrator, all standing in front of a "Number One" banner. (Courtesy of Jim Kanno.)

Seen here on top of Saddleback Mountain with Orange County fire authority officials in 1960 are, from left to right, Joe Callens, Charles Ishii, an unidentified fire official, Bud Klecker, Jim Kanno, Henry Boer, and fire official Joe Sherman. Fountain Valley did not have a fire department until June 1964. Up until that time, the county provided protection out of its station at Midway City, and volunteers also responded out of Huntington Beach. (Courtesy of Jim Kanno.)

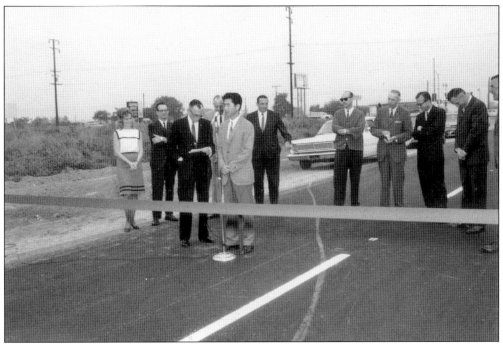

With the city being new, such scenes as this 1967 ribbon-cutting ceremony for a new road attended by Mayor Jim Kanno were a common sight. (Courtesy of Orange County Archives.)

This photograph was shot from the rooftop of Fountain Valley City Hall in September 1968. This is the site for the then-new community center and police facility. Visible in the background is a new bridge, which had just been completed in 1966, over the 405 Freeway. The 405, or San Diego Freeway, bisects Fountain Valley diagonally northwest to southeast. (Courtesy of City of Fountain Valley.)

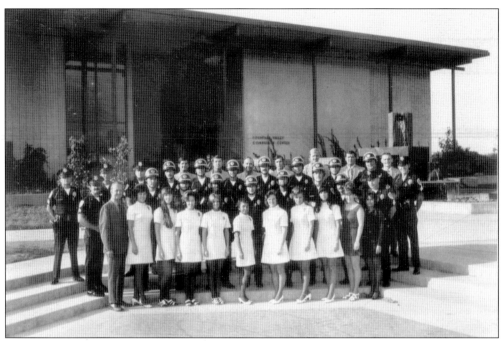

Standing in front of the new community center and police facility is the department staff, whose numbers grew steadily. Note one of the city's only fountains on the right in the background. (Courtesy of City of Fountain Valley.)

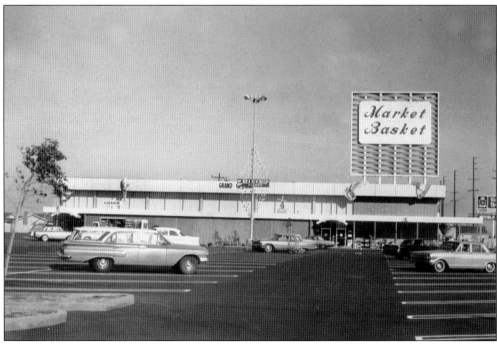

This is the new grocery store during its grand opening on Garfield and Magnolia Streets in February 1965. Other new stores in the city would be Gemco on Brookhurst Street and Warner Avenue and Zody's on Harbor Boulevard and Edinger Avenue. (Courtesy of City of Fountain Valley.)

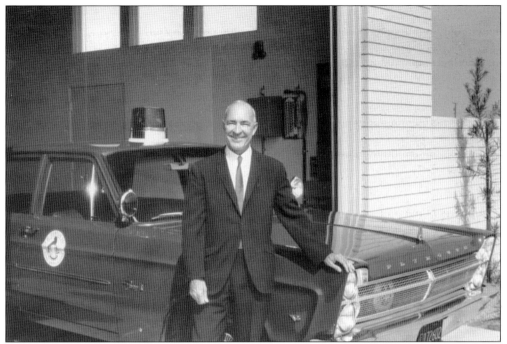

This photograph is dated 1966 and shows city manager James Neal. A second fire station was built on Newhope Street, just north of Warner Avenue, and was named the Abel Stearns Station in 1966. The station house in this photograph is unidentified. (Courtesy of City of Fountain Valley.)

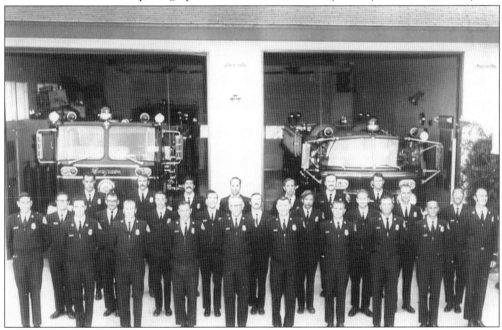

This early 1960s photograph shows the growing numbers of firemen on staff. The first fire chief, Mickey Lawson of Signal Hill, is pictured here front row center with eyeglasses on. His first responsibilities were to plan and design the stations, acquire the land, and obtain equipment and manpower. (Courtesy of City of Fountain Valley.)

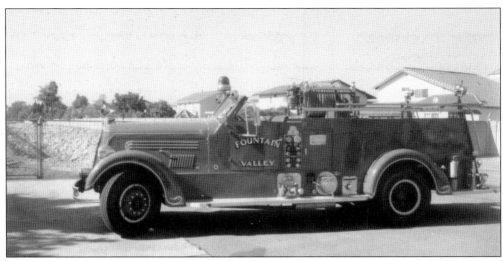

Parked behind Station No. 2 is a 1949 Seagrave purchased by the city in 1967 from the Signal Hill Fire Department for use as a reserve engine. It remained on active duty until the early 1980s, when it was placed on historical duty. Note one of Fountain Valley's original, pre-city drainage ditches in the background. (Courtesy of Ron Chamberlain.)

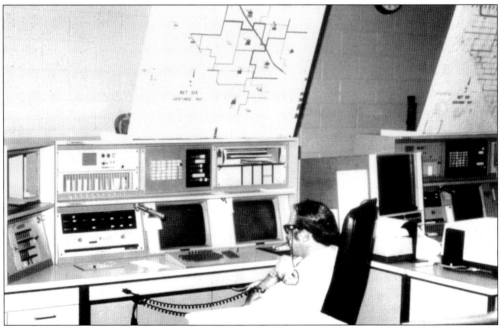

In 1973, the first joint-powers agreement covering training and communications in a multifaceted, "Net Six" fire department program was launched. This program included fire departments in the cities of Fountain Valley, Huntington Beach, Westminster, and Seal Beach. This is a photograph of that control room, located in Huntington Beach. (Courtesy of City of Fountain Valley.)

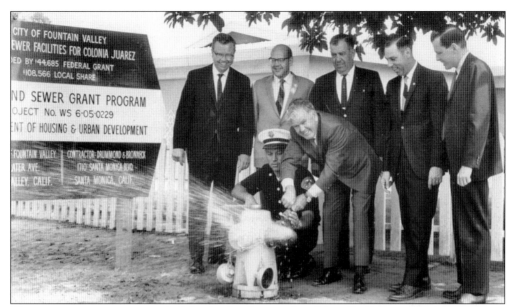

This improvement project with federal aid culminated on May, 29, 1969, in the Colonia Juarez section of Fountain Valley with a dedication of the improvements. Congressman Richard T. Hanna (D-Fullerton) and Mayor Schwerdtfeger, as well as representatives of the Department of Housing and Urban Development and members of the colony, were on hand. Also present just off camera was councilman Ruben Alcala, whose daughter, Lydia Alcala, was the first Miss Fountain Valley. (Courtesy of City of Fountain Valley.)

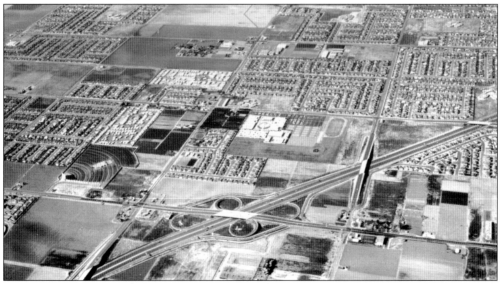

This photograph, taken on January 3, 1967, shows how much the city had grown in less than 10 years. Fountain Valley High School's football field and track can be seen on Bushard Street just south of Slater Avenue. Following Slater east over the newly built 405 Freeway to the bottom of the photograph, one can see city hall and the area that would later be developed for the police department, U.S. post office, library, and community center. Just about midway down and to the left in the photograph stands the Fountain Valley Drive-In on Brookhurst (formerly known as Wright and also Nimock Street) just south of Talbert Street. (Courtesy of Jim Kanno.)

In the city yard on Ward Street, just a stone's throw from the San Diego Freeway, was this police firing range. Other cities would rent time for their police departments to use this range. A few years after this photograph was taken, a football field was built next to the range to be used for Pop Warner junior-league football. The Fountain Valley Police Department once coached a football team and used this firing range for a practice field because it was lighted. The author played on that team. In recent years, the football field and range has been replaced by a recreational vehicle and motor home sales lot. (Courtesy of City of Fountain Valley.)

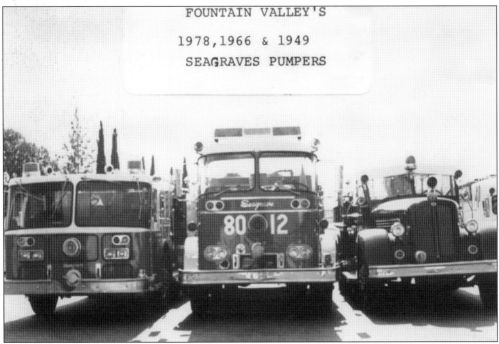

FOUNTAIN VALLEY'S

1978,1966 & 1949

SEAGRAVES PUMPERS

These three fire rigs were owned and operated at the same time in the city. (Courtesy of City of Fountain Valley.)

Here, on Slater Avenue looking south, is city hall today. Directly across the street was the city's second U.S. post office, which became Silky Sullivan's restaurant. The first post office was Tom Talbert's general store on Bushard Street. (Courtesy of Michael Douglas Gibb.)

The city's 50th anniversary of incorporation was June 13, 2007, as this book went to press. These banners were placed on streetlight poles on Brookhurst Street and Slater Avenue. (Courtesy of City of Fountain Valley.)

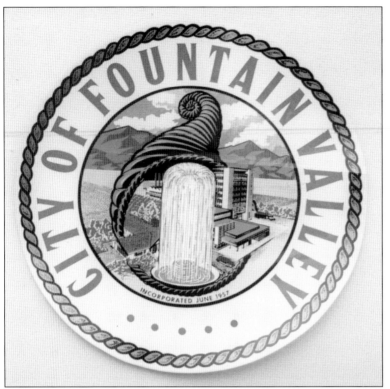

This is the City of Fountain Valley's original city seal, with the cornucopia in the center representing the abundance of crops that were grown in the city's agrarian past, and the Saddleback Mountain range in the background. (Courtesy of City of Fountain Valley.)

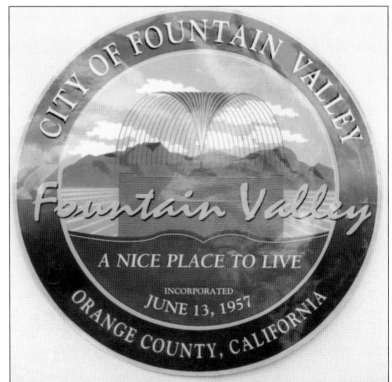

In recent years, the seal was replaced with the one seen here. The city's population in 2007 numbered more than 55,000. (Courtesy of City of Fountain Valley.)

Four

FLIGHT

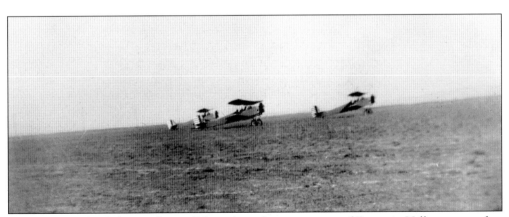

This photograph of planes taking off shows how the open spaces of Fountain Valley were perfect for takeoffs and landings by the local pilots and crop dusters who regularly flew in the area. (Courtesy of Joseph Louis Betschart.)

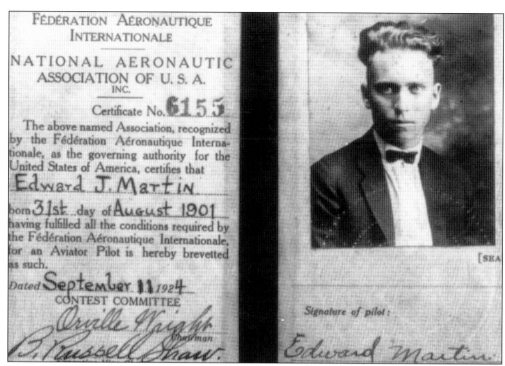

This is a copy of Eddie Martin's pilot's license. Martin was born in 1901 in San Jacinto in Riverside County and grew up in the Newhope community of the Fountain Valley area. As a barnstormer, Eddie later founded the Eddie Martin Airport, which ultimately became the Orange County Airport, now referred to as John Wayne Airport. Note the signature on Eddie's license is that of Orville Wright, of the Wright brothers fame. (Courtesy of First American Title.)

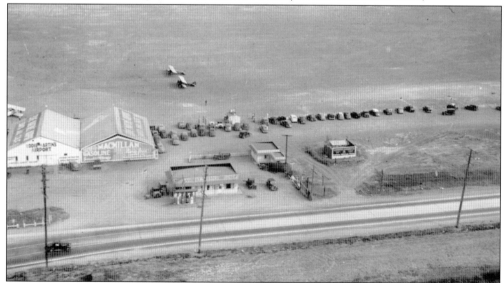

This 1935 aerial shot of the Eddie Martin Airport shows its hangers, café, and wide-open spaces. The Orange County Airport finally materialized southeast of the original location. The airport was later named for film actor John Wayne, who lived in nearby Newport Beach. (Courtesy of Joseph Louis Betschart.)

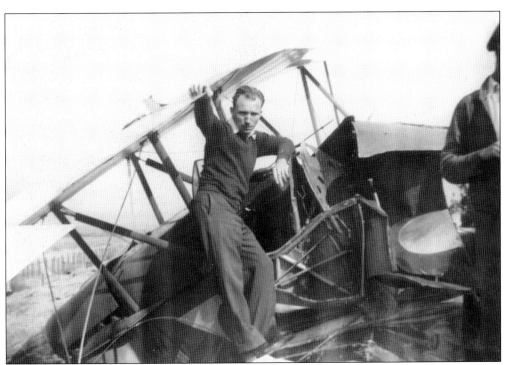

This is Eddie Martin's brother, Johnny Martin, looking over a airplane that had crashed in the area. No one was killed. (Courtesy of Joseph Louis Betschart.)

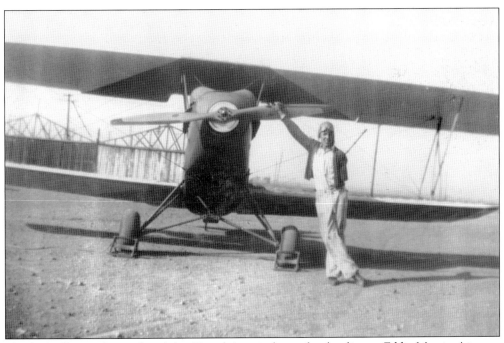

Floyd Wardlow is depicted with his Travel Air airplane after landing at Eddie Martin Airport. The structures in the background were the early buildings of the airport. (Courtesy of Joseph Louis Betschart.)

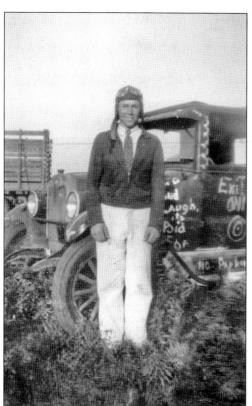

A young Louis Betschart is depicted. His father, Joseph Sr., leased the slaughterhouse called Talbert Meat from August Martel, who had founded that enterprise in 1907. Louis Betschart and Floyd Wardlow later modified this car even further by cutting off the roof with his dad's butcher saw to make an early convertible. (Courtesy of Joseph Louis Betschart.)

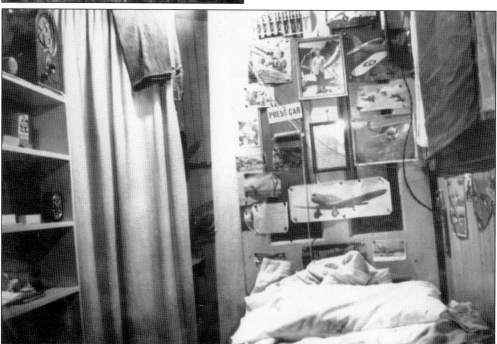

This is Louis Betschart's bedroom, where, as a young boy, his dreams and aspirations were clearly represented on the wall. (Courtesy of Joseph Louis Betschart.)

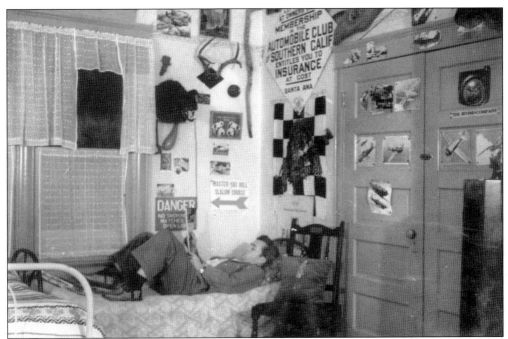

Louis Betschart is depicted a bit older in a bigger room, but it is clear his aspirations are still the same. Note on the right-hand side of the photograph a sign that reads, "Irvine Company." (Courtesy of Joseph Louis Betschart.)

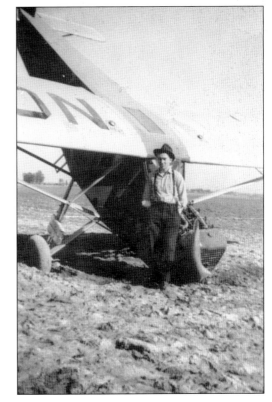

This is Louis Betschart in December 1936 posing in front of an unsuccessful landing. He stated to this author that he wasn't paying attention because he was watching people watch him land, and failed to notice the soft soil that had been plowed under, causing his wheels to dig in. Half of the propeller is buried under ground. (Courtesy of Joseph Louis Betschart.)

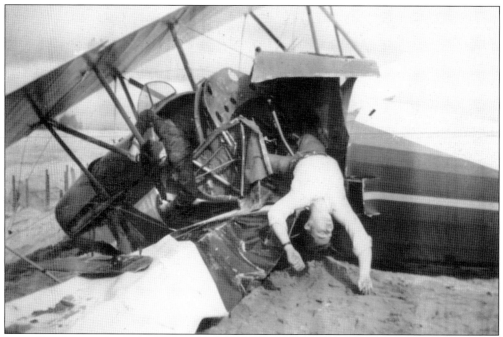

Louis Betschart and a friend decided to use this local wreckage for a photo opportunity. They were not involved in the crash, no one was killed, and they just thought it would be a great photograph. (Courtesy of Joseph Louis Betschart.)

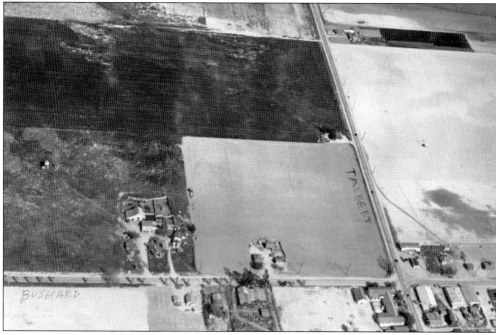

This aerial shot of Talbert Avenue and Bushard Street shows the Fountain Valley School on the northwest corner and, further north, the Wardlow property, which was adjacent to and across the street from the Betschart slaughterhouse. Louis Betschart took this photograph from his plane in the 1930s. (Courtesy of Joseph Louis Betschart.)

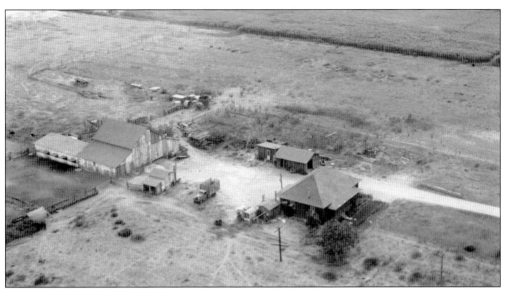

Here is another aerial photograph that Louis Betschart took of his home. (Courtesy of Joseph Louis Betschart.)

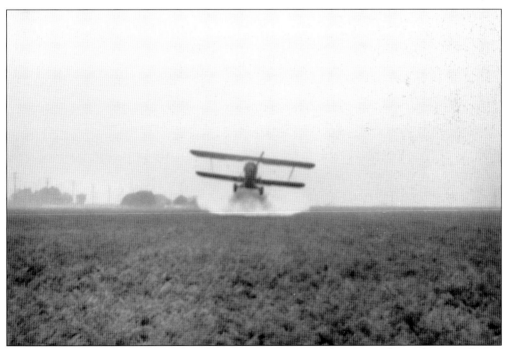

Seen here is a typical scene of mid-20th-century Fountain Valley, a crop duster doing work over the Lamb property, near Bushard and Garfield Streets, which would later become the border of Huntington Beach and Fountain Valley. (Courtesy of Earl Lamb.)

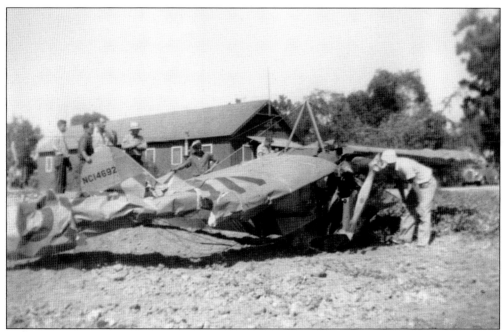

The two occupants of this Aeronca C-3 died when their plane crashed. Due to the slow speeds of the small planes used in the area and the ability for them to glide, very few of the pilots were killed. The pilot of this aircraft was said to be attempting aerobatic maneuvers. The plane was owned and operated as a trainer out of Eddie Martin Airport. (Courtesy of Joe Betschart.)

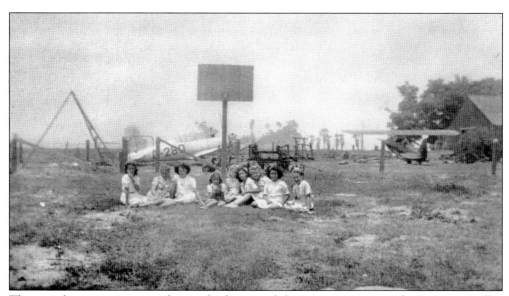

These students are sitting in the north playground during recess time at the Fountain Valley School. Taken in 1947, the image shows planes on the Wardlow property in the background. (Courtesy of Lillian Garcia.)

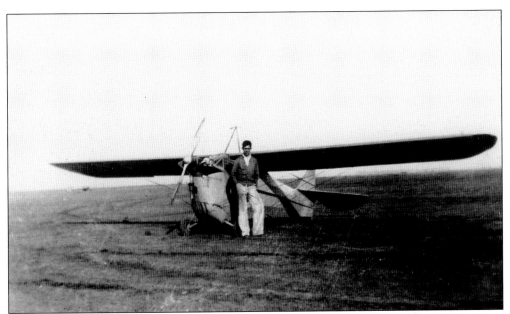

This 1936 picture of Floyd Wardlow with his Aeronca C-3 depicts the same type of plane seen on the previous page. They were extremely popular at the time. The Aeronca C-3, nicknamed the "Flying Bathtub" (because of its shape), was manufactured from 1931 to 1937. With room for two adults and just 36 horsepower, the C-3 proved itself as a low-cost, reliable airplane. (Courtesy of Wardlow family.)

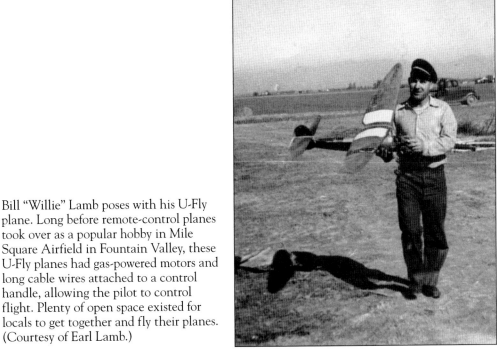

Bill "Willie" Lamb poses with his U-Fly plane. Long before remote-control planes took over as a popular hobby in Mile Square Airfield in Fountain Valley, these U-Fly planes had gas-powered motors and long cable wires attached to a control handle, allowing the pilot to control flight. Plenty of open space existed for locals to get together and fly their planes. (Courtesy of Earl Lamb.)

This is a typical scene for the local hobbyists out flying their U-Fly planes. (Courtesy of Earl Lamb.)

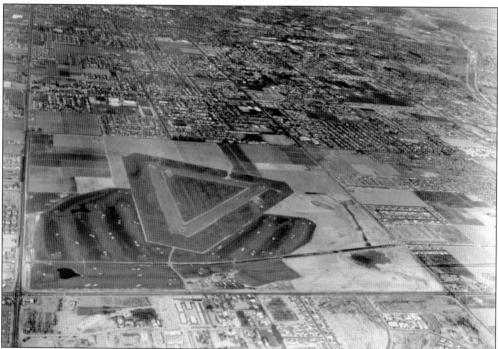

At the time of this 1969 aerial view of Mile Square outlying landing field, it had been transferred from the US. Navy at Los Alamitos to the Marine Corps at Tustin for helicopter training. This rural area of Fountain Valley was sparsely populated in 1943, when it was purchased by the navy. The area was ideal for emergency landings and training, with low risk to the civilian population. The recently finished golf course can be seen just north of Colonia Juarez on Warner Avenue (lower center). To the right of the golf course, the two lakes of the developing Mile Square Regional Park are being excavated. The line through the center running east and west is a drainage ditch, which is still there today, and at the top right is the Santa Ana River running north to south near Harbor Boulevard. (Courtesy of First American Title.)

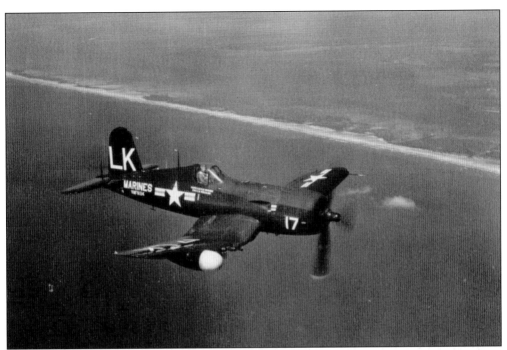

Fixed-wing aircraft, such as this F4U-4B Corsair, was the type of aircraft that flew in and out of Mile Square Auxiliary Air Field from its inception until the 1950s. (Courtesy of Flying Leathernecks Aviation Museum.)

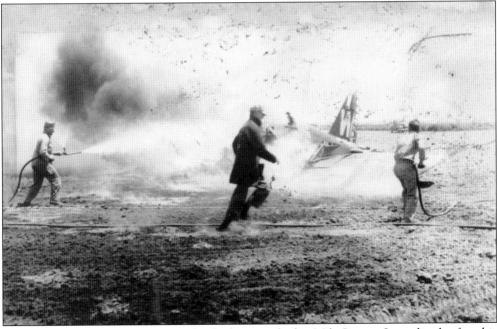

This scene is of an F4U-4B Corsair that had just crashed at Mile Square. Immediately after this photograph was taken, the photographer was approached by military personnel who insisted that further picture taking stop. Ironically, years later, this photograph was actually saved by the photographer from his burning home. (Courtesy of Mas Masuda.)

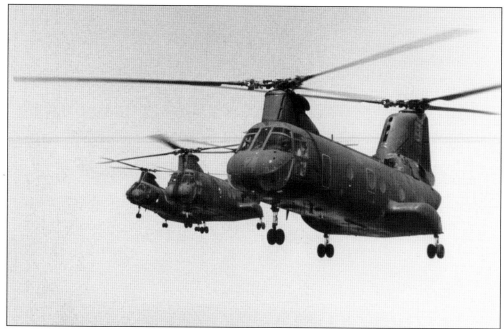

In 1952, the U.S. Marines took over the blimp base at what became Marine Corps Air Facility Tustin. The marines turned the blimp base into a helicopter base, and helicopters landed and took off at Mile Square Field until it closed in 1974. Here are three CH-46 Sea Knight helicopters, which would routinely practice maneuvers at Mile Square. (Courtesy of Flying Leathernecks Aviation Museum.)

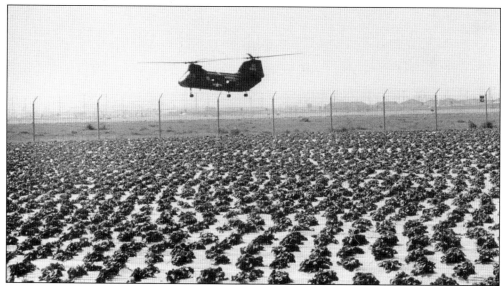

This picture was taken in 1969 from Mile Square Park and shows not only the helicopters practicing "touch-and-go" maneuvers, but also the proximity of the housing tracks in the background and the strawberry fields in the foreground. This author has vivid memories growing up with kitchen windows rattling from the vibrations of these helicopters. By the mid-1970s, that sound was replaced by the daily buzzing of remote-controlled airplanes flown by hobbyists. (Courtesy of Steve Bonhall.)

This poster was for the Gordon Bennett Balloon Race held in Mile Square in April 1980. In 1980, the Gordon Bennett Balloon Race was moved to Fountain Valley. This event was attended by 13 balloon teams, and they all competed for an internationally renowned trophy. The first race occurred in Paris, France, in 1906, when more than 100,000 people lined the banks of the Seine River to watch the launch. This new competition among aeronauts of different countries received great interest. Seven different nations entered balloons. (Courtesy of Mrs. Dixie Merrill.)

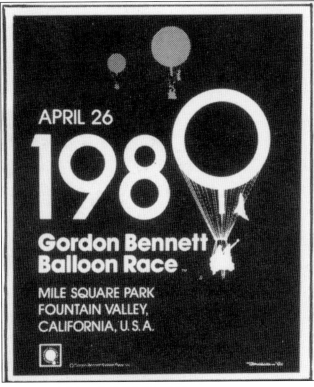

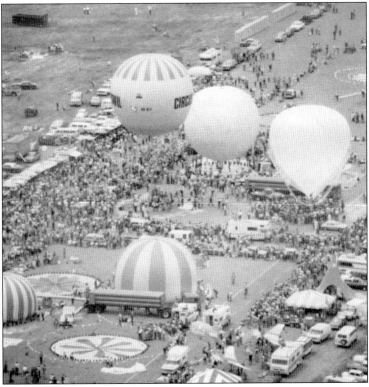

This aerial photograph of the 1980 balloon race shows racers filling their balloons in preparation for the launch. Unlike the hot-air balloons of today, these were gas-filled balloons. Ever since the tragic loss of the dirigible Hindenburg in 1937 in New Jersey, gas ballooning has tapered off in the United States. (Courtesy of Mrs. Dixie Merrill.)

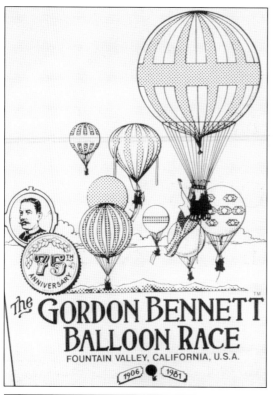

This is the poster of the 1981 Gordon Bennett Balloon race, held in Mile Square in April 1981. "Balloon mail" was offered during this race. A special postmark could not be applied until the day of the race itself. The philatelists staged a midnight rendezvous at the U.S. post office to tackle the job of cancelling all the balloon mail before dawn for the teams to deliver. Balloon mail was truly the first form of air mail. Its classic beginning dates back to 1870, during the Franco-Prussian War, when messages carried via balloon became a lifeline for vital communications. (Courtesy of Mrs. Dixie Merrill.)

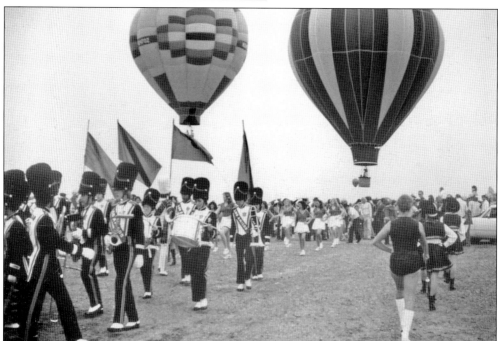

This picture was taken at the opening day ceremonies of the 1981 Gordon Bennett Balloon Race, showing Fountain Valley's Los Amigos High School marching band. (Courtesy of City of Fountain Valley.)

Five

SCHOOLS, CHURCHES, PARKS

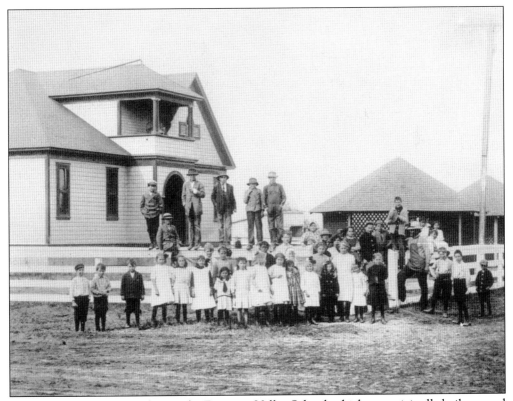

This photograph, c. 1913, depicts the Fountain Valley School, which was originally built around the beginning of the 20th century. (Courtesy of Earl Lamb.)

Here is the program from the school's first graduating class in 1903. It has a green ribbon woven through it. (Courtesy of Hazel Courreges.)

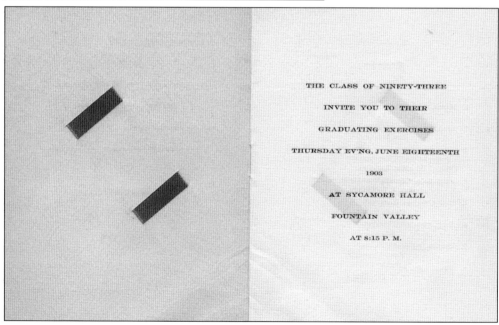

THE CLASS OF NINETY-THREE

INVITE YOU TO THEIR

GRADUATING EXERCISES

THURSDAY EV'NG, JUNE EIGHTEENTH

1903

AT SYCAMORE HALL

FOUNTAIN VALLEY

AT 8:15 P. M.

On page one of the graduation program, note the typographical error on the date reading, "ninety three." The ceremony was held at Sycamore Hall. (Courtesy of Hazel Courreges.)

Program

1. March, "First Regiment,"
 MRS. C. F. WARD.
2. Invocation,
 REV. HEALEY.
3. Salutatory and Oration, "The Present Policy of the United States." ..
 WM. JOHNSON.
4. Piano Solo, "Moonlight on the Hudson,"
 MRS. J. L. TAYLOR.
5. Essay, "School History,"
 PEARL SWIFT.
6. Song, "Students' Struggle,"
 SCHOOL.
7. Oration, "Use of Flowers,"
 FRED YEARY.
8. Violin Solo,
 T. B. TALBERT.

Program, continued.

9. Essay, "Nature,"
 JESSIE COURREGES.
10. Song, "Rocked in the Cradle of the Deep."
 MR. C. F. WARD.
11. Oration, "The Battle of Manila,"
 HUGO LAMB.
12. Essay, "Class Prophecy,"
 GERTRUDE AMBROSE.
13. Piano Solo, "Triumphal March," ..
 MRS. J. L. TAYLOR.
14. Essay, "Class Poem,"
 EVA DUNN.
15. Valedictory,
 GERTRUDE AMBROSE.
16. Presentation of Diplomas, Co., Supt., of Schools,
 J. B. NICHOLS
17. "Shall a Parting be Forever," ..
 MRS. J. L. TAYLOR, MR. C. F. WARD

Note the names of pioneering families Wardlow and Lamb and Tom Talbert, who performed a violin solo for entertainment. (Courtesy of Hazel Courreges.)

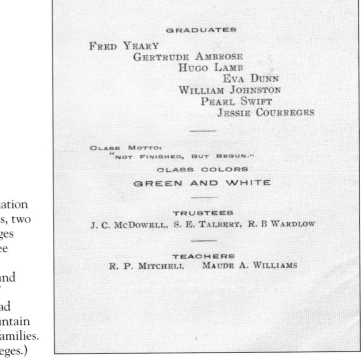

GRADUATES

FRED YEARY
GERTRUDE AMBROSE
HUGO LAMB
EVA DUNN
WILLIAM JOHNSTON
PEARL SWIFT
JESSIE COURREGES

CLASS MOTTO:
"NOT FINISHED, BUT BEGUN."

CLASS COLORS
GREEN AND WHITE

TRUSTEES
J. C. MCDOWELL, S. E. TALBERT, R. B WARDLOW

TEACHERS
R. P. MITCHELL MAUDE A. WILLIAMS

The last page of the graduation program lists the graduates, two of which are Jesse Courreges and Hugo Lamb. The three trustees named are J. C. McDowell, Sam Talbert, and R. B. Wardlow. All five of these people eventually had elementary schools in Fountain Valley named after their families. (Courtesy of Hazel Courreges.)

NOTICE OF HEARING

—OF THE—

Petition for Change of Boundaries

Of School Districts.

●■●

A petition has been presented to the County Superintendent of Schools of Orange County, State of California, for a change of boundaries of ___Fountain Valley___

and ___Bolsa___ School Districts by

taking from ___Bolsa___ School District

and adding to ___Fountain Valley___ School District

the following territory: ___Beginning at the North east corner of___

___the south east quarter of Sec. 19 town ship 5 South, Range 10 West___

___thence West 3/4 miles to district boundary.___

All parties interested will have a hearing at the office of the Board of Supervisors of Orange County, California, in the city of Santa Ana, on ___March 9___, 1903 at the hour of ___11 to 12___.

___J.B. Nichols___

Dated at Santa Ana, ___Feb. 25___, 1903. County Sup't of Schools.

This is a posted notice dated February 25, 1903. These boundary changes came about from time to time throughout Orange County, because it was easiest to move boundaries to make it more practical for the children to attend schools closer to their homes. (Courtesy of Orange County Archives.)

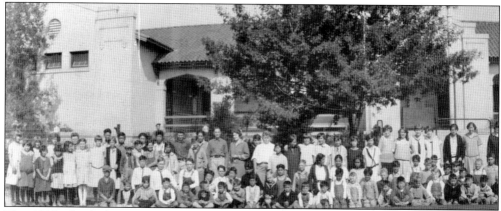

This 1925 school photograph shows half the student body of Fountain Valley School in front of their relatively new schoolhouse on the corner of Bushard Street and Talbert Avenue. It was built in 1920. (Courtesy of Fountain Valley Historical Society.)

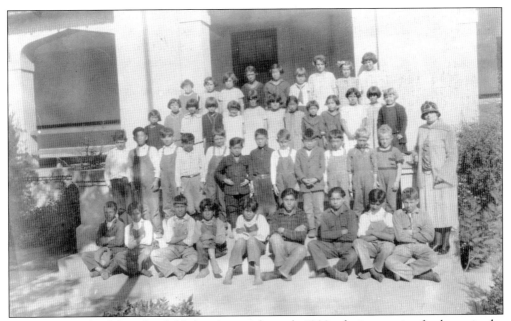

This photograph of the school, likely taken in the early 1900s, depicts a mix of cultures in the farming community of Talbert, later known as Fountain Valley. Note the barefooted children, although it was understood in those days that girls always wore shoes to school. (Courtesy of Fountain Valley Historical Society.)

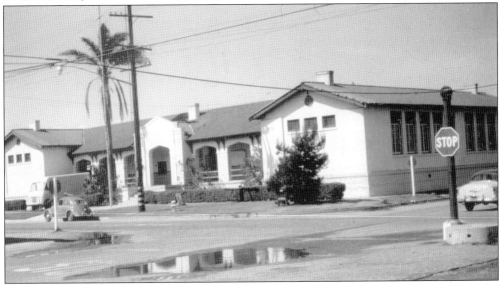

The "new school," built in 1920 at Bushard Street and Talbert Avenue, is shown here in the 1950s. By 1962, the front was being used as a makeshift Fountain Valley City Hall until 1964, when the new city hall and library on Slater Avenue, just east of Brookhurst Street, was finished. The new facilities were dedicated on January 23, 1965. Although this school changed over the years as new structures were added, it remained Fountain Valley Elementary School until recently, when it was demolished and replaced with Founders Village Senior Center. At the entrance to the lobby stands the original bell from the school that was built in 1920. (Courtesy of City of Fountain Valley.)

This is the program from the graduating class in 1921 of the new school at Bushard Street and Talbert Avenue. (Courtesy of Hazel Courreges.)

Fountain Valley

May 20, 1921

Class Roll:
Frances Chandler
Dedah Gilbert
Blanch Helm
Elva Titus

Class Motto
Strive and Succeed

Class Colors.
Pink and Green

Class Flowers
Cecil Bruners and Fern

The inside page of the 1921 graduating program shows only four graduates. Attendance was low during that period in the sparsely populated farming community. (Courtesy of Hazel Courreges.)

This school bond was issued in 1920 to help raise funds for the Fountain Valley School District. The total issue was $24,000. (Courtesy of Orange County Archives.)

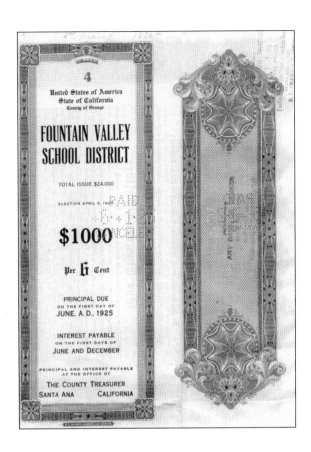

Taken c. 1934, this broad shot is of the Japanese school, which was built in 1912 and was located near the southwest corner of Talbert Avenue and Bushard Street. Japanese children would attend this school on weekends, and sometimes after regular school. Note the basketball backboard on the left side. (Courtesy of Taikichi Kato family.)

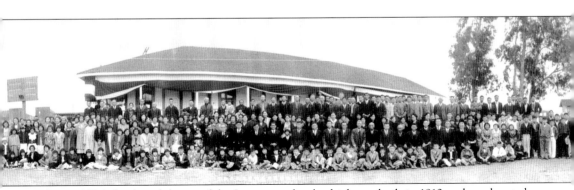

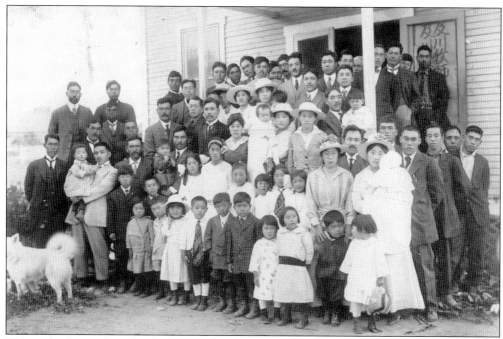

This is the front of another Japanese school in Talbert (Fountain Valley). These schools were intended to preserve the heritage and culture of the Japanese homeland through the study of the history, customs, and language of their ancestors. Note the Japanese writing on the inside of the door. (Courtesy of Jim Kanno.)

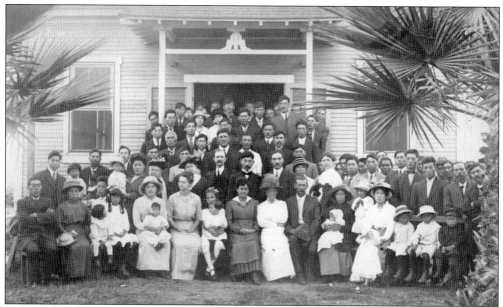

This photograph of a Japanese school and community center was given to Suzie Kato by Margaret Talbert of Huntington Beach. In this group is future California justice Stephen K. Tamura's father. The son was the first Asian American justice to sit on the California Court of Appeals, and he later served as justice pro tem of the California Supreme Court. (Courtesy of Taikichi Kato family.)

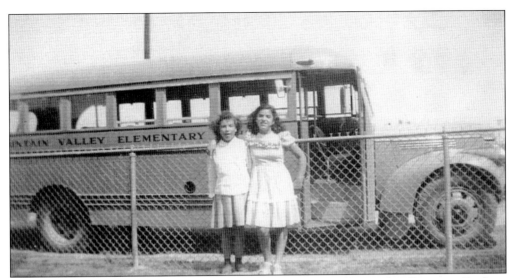

Picture here in 1948 are Lillian Garcia, in the eighth grade, and fellow student Rosemary Sterling, in the sixth grade, in front of the community's new school bus, parked along Bushard Street. Lillian Garcia was president of the Fountain Valley Historical Society as this book went to press in 2007. (Courtesy of Lillian Garcia.)

This is Lillian Garcia and some fellow students with their principle, Mr. Sharp, approaching their graduation date. (Courtesy of Lillian Garcia.)

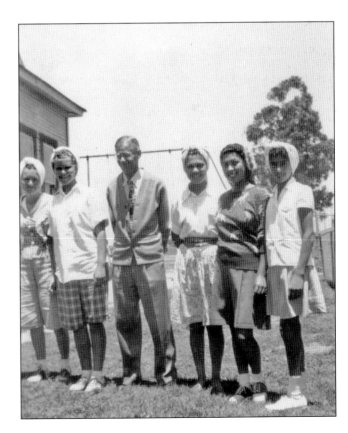

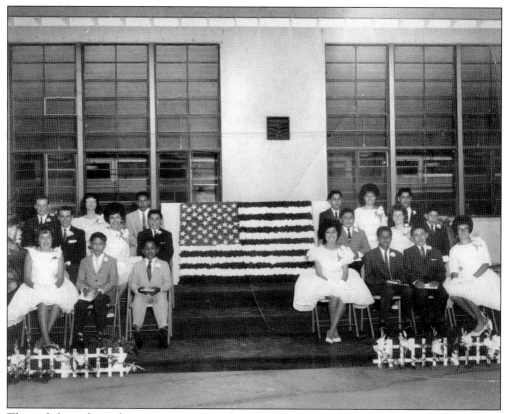

The eighth-grade graduation ceremony at the Fountain Valley School is shown during its 1962 edition. These students would go on to Huntington Beach High School, since Fountain Valley High School was not yet built. (Courtesy of Wardlow family.)

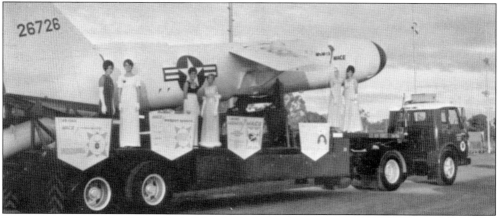

Representing Fountain Valley High School, the homecoming queen and her court are seen in this image with the rocket on loan from the nearby aerospace industry. The caption on this high school photograph reads, "Candidates have high hopes." This rocket was part of the MACE Weapons Systems of the cold war era. (Courtesy of Fountain Valley High School.)

This is a current picture of the gymnasium at Fountain Valley High School. Opened on September, 12, 1966, with 2,300 students, the school had, by the mid-1970s, the highest enrollment west of the Mississippi River, with more than 4,300 pupils. The annual football game with rival Edison High in Huntington Beach had to be held at Angels Stadium in Anaheim because of the crowd size. The FVHS principal was Dr. Paul Berger. A few of the noteworthy alumni include actress Michelle Pfeiffer; eight-time Olympic medal winner, with one of those a gold for the freestyle relay, swimmer Shirley Babashoff; Pacific-10 career touchdown leader at Stanford and 1985 Super Bowl champion with the Chicago Bears, Ken Margerum; and 11-year NFL veteran with the Los Angeles Rams and Pittsburgh Steelers, Duval Love. This gymnasium can be seen in the 1997 film *Wag the Dog*, along with banners with the school song. (Courtesy of author.)

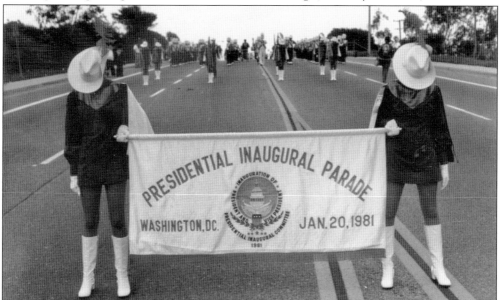

During a 1981 parade that ended at the recreation center at Heil and Brookhurst Streets, the Fountain Valley High band marched down Bushard Street and paused at Warner Avenue to pose for the photographer. This banner was used earlier in the year when the band was selected to represent president-elect Ronald Reagan's home state of California in the inaugural parade down Pennsylvania Avenue on January 20, 1981. (Courtesy of City of Fountain Valley.)

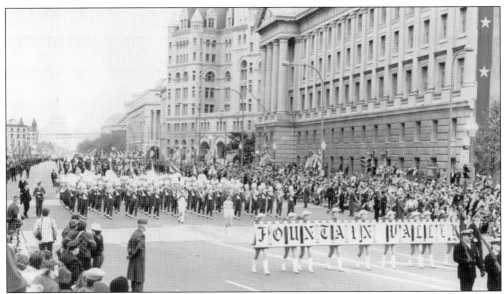

In this 1981 photograph, the Fountain Valley High School Marching Band can be seen coming down a cold Pennsylvania Avenue in the presidential inaugural parade. A faint image of the Capitol can be seen in the background. (Courtesy of Fountain Valley High School.)

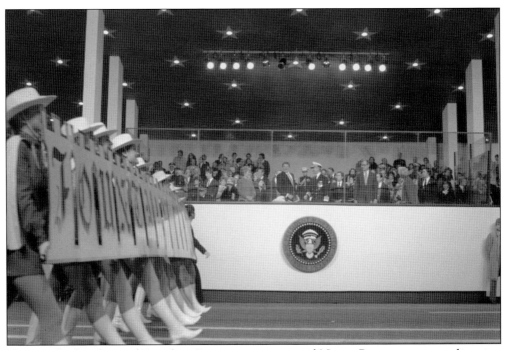

Here, as the band passed President Reagan, witnesses said Nancy Reagan was seen directing the president's attention to the band, which was representing him and his state of California. (Courtesy of Ronald Reagan Library.)

This is Los Amigos High School, which opened in September 1968 with only ninth and tenth graders admitted during its first year. The enrollment at that time was about 940 students. Hal Butler was the principal. Although within the city of Fountain Valley, this school is located on Newhope Street south of Warner Avenue near the city border, and is actually part of Garden Grove Unified School District. Fountain Valley High School is part of the Huntington Beach Unified School District. Due to the schools' location, the Los Amigos student body is made up of kids from the cities of Santa Ana, Garden Grove, and Westminster, as well as from Fountain Valley. (Courtesy of author.)

This is the new Fountain Valley School District building at the corner of Slater Avenue and Brookhurst Street, across from the police station. In prior years, the district offices occupied vacant elementary schools that had been closed due to declining enrollment. (Courtesy of author.)

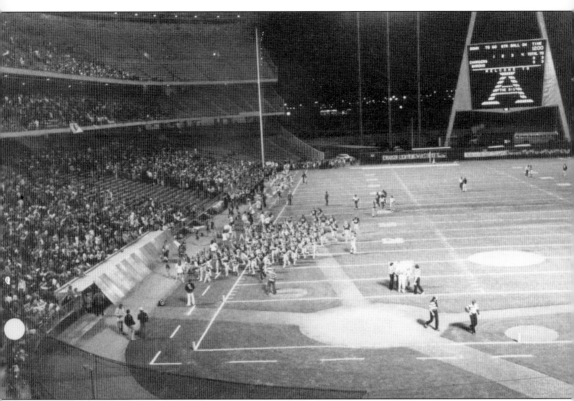

This is the Big "A" Anaheim Stadium in the 1980s; it was the home of the California Angels and the Los Angeles Rams. The big rivalry game between Edison High School of Huntington Beach and Fountain Valley High School had a combined student body that was so large no other local stadium was big enough to hold them. For years, the game was held at this stadium. In this pregame photograph, one can see the band lining up to go to their seats and the very large area reserved for them. This yearly game is also for bragging rights, and the winning team gets to keep a large bell symbolizing the rivalry at its school for the year. The first head coach was Bruce Pickford, and the current coach is John Shipp. (Courtesy of Fountain Valley High School.)

Around the beginning of the 20th century, Tom Talbert donated land and $50 toward building the "country church of Talbert" at the crossroads of this developing town. It was the first church in town. The land was deeded to the Methodist Church South. Before this, most people attended the Greenville Church in an area northeast of town. As roads and modes of transportation got better, many members went back to the Greenville Church and the church at Talbert fell on hard times, marked by different itinerant preachers using it for revivals, then moving on. In 1908, there was an "uplift society" for children who were required to "take the pledge." This was an oath not to swear, chew tobacco, or smoke, among other things. Currently the Anglican Episcopal Church of North America owns and operates this All Saints' Anglican Church of Fountain Valley. (Courtesy Mrs. Darby Templin.)

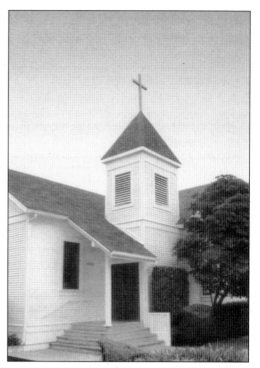

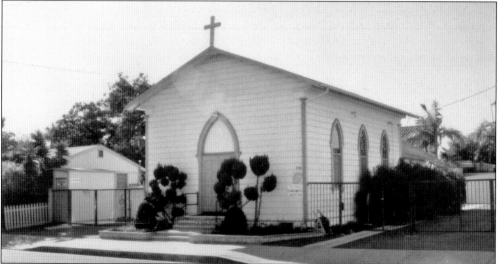

In 1923, the Mexican community of Colonia Juarez was developed on the southwest corner of Wintersburg Avenue (now Warner Avenue) and Ward Street, just across from what would become the navy's airfield at Mile Square. The developers named it in honor of Mexican hero Benito Juarez. They also named four streets, one of which is Avenida Cinco De Mayo. It is thought to be the first of the many *avenidas* throughout the county by the county's archivist Phil Brigandi. The Colonia was complete with a community center, store, church, and recreational facilities. Besides horse and buggy or bicycles for transportation, the residents could walk a mile south to the corner of Talbert Avenue and Ward Street to board the Pacific Electric Red Car and take the interurban to either Santa Ana or Huntington Beach. This church was relocated from Westminster. (Courtesy of author.)

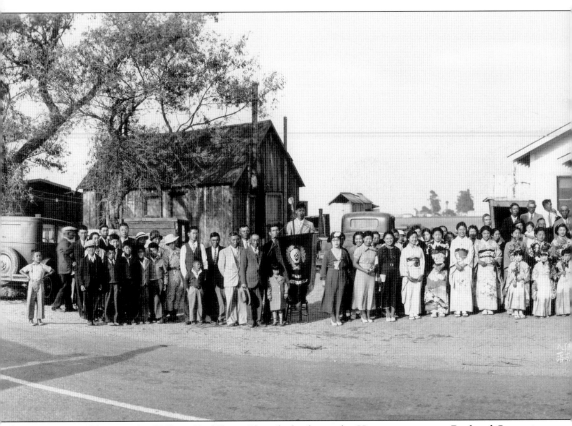

Pictured here is the Talbert Buddhist Church, built on the Kato property on Bushard Street in 1935. This photograph was taken during the dedication ceremony in 1936 of the first Buddhist Church in Orange County. By 1931, Sunday school was being held at the Japanese school. By 1933, the Young Men's Buddhist Association was formed with Paul Nagamatsu of Talbert as charter president. In 1935, it became the YBA, or Young Buddhist Association. After World War II, many of the displaced and interned Japanese returned to the area from the relocation

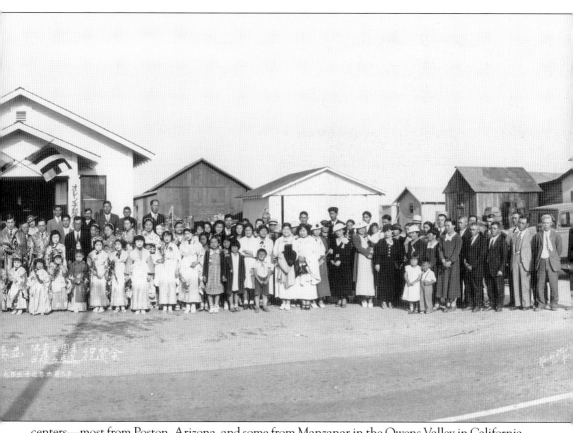

centers—most from Poston, Arizona, and some from Manzanar in the Owens Valley in California. The church was reopened as a hostel for displaced people in 1946. After people were resettled to homes, Sunday school resumed on Saturdays and was followed by Japanese-language school in the afternoons, because Sundays were workdays for farmers. In 1958, the church moved to Stanton and was incorporated on May 6, 1963. (Courtesy of Taikichi Kato family.)

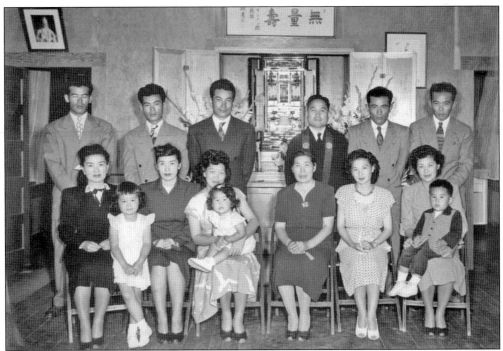

This is a memorial service held inside the Buddhist church for Taikichi Kato, whose land the church was built on. This memorial service was held on July 10, 1948, although he died in 1942. Pictured here are Ume Kato, her five sons and two daughters, three daughters-in-law, three grandchildren, and Reverend Hayajima. (Courtesy of Taikichi Kato family.)

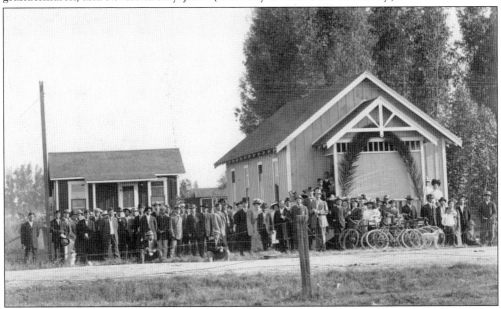

This is Wintersburg Presbyterian Church in the community of Wintersburg, which became part of Huntington Beach. It was located, appropriately enough, on Wintersburg Street, which eventually became Warner Avenue. It had a large Japanese congregation coming from communities all around the area. This photograph was taken some time in the 1920s. (Courtesy of Jim Kanno.)

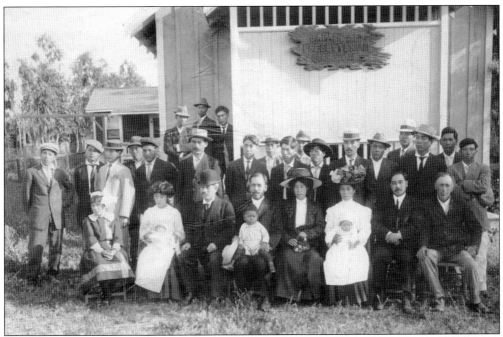

This is the side of the Wintersburg Church that was opened in 1904. This photograph is from 1911, and the sign reads, "Japanese Presbyterian Mission." The Caucasian in the photograph is believed to be from the Westminster Church. (Courtesy of Jim Kanno.)

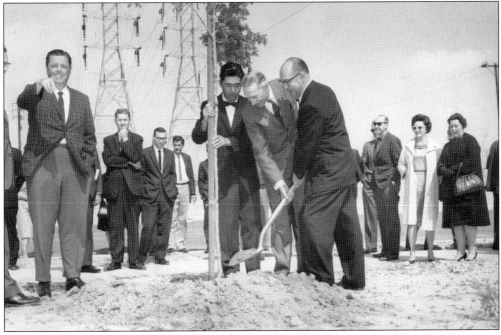

Shown here in 1963 is the groundbreaking for the first park in Fountain Valley, called Westmont Park. Planting the first tree are, from left to right, Mayor Jim Kanno, county supervisor Cye Featherly, and an Edison Company official. The park is located beneath Edison power lines. (Courtesy of City of Fountain Valley.)

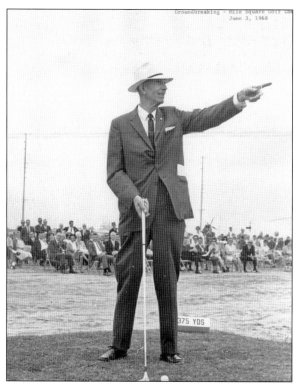

Here is county supervisor Cye Featherly in 1968, calling his shot as he's about ready to tee off from a patch of sod at the groundbreaking ceremony for Mile Square Golf Course. Various officials are in attendance, and that's a helicopter rotor blade behind them. A former 640-acre bean field now known as Mile Square Regional Park, it was acquired by the navy in 1943. A triangular-shaped airstrip was constructed to simulate aircraft carrier landings. After World War II, it was shifted from the U.S. Navy to the Marine Corps and used for helicopter training. With post–Vietnam War de-escalation and the rapid development of Fountain Valley, this area became reclassified as government surplus. An agreement was reached with the government to convert this land for public use. (Courtesy of Orange County Archives.)

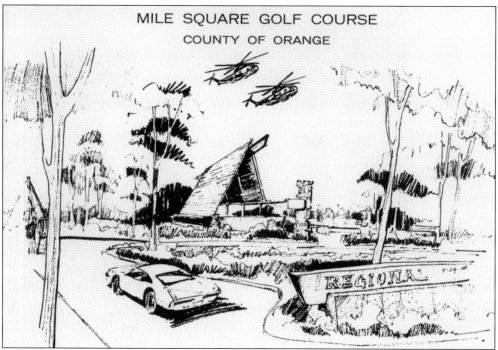

This was the program/invitation from the Orange County Board of Supervisors to the groundbreaking ceremony on June 3, 1968, for the new Mile Square Golf Course. Note the military helicopters in the drawing. (Courtesy of Orange County Archives.)

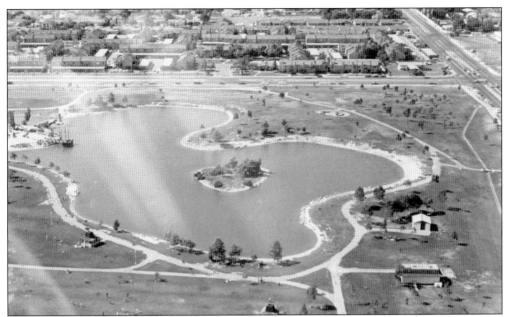

In this aerial view of the newly developed north lake in Mile Square Park near the intersection of Edinger Avenue (formerly Smeltzer) and Euclid Avenue (formerly Verano), a condominium complex named "Fountain Park" can be seen toward the top of the picture. Just beyond that complex are the Fountain Valley city limits. Following in a westerly (left) direction, within a half a mile, Fountain Valley shares a border with the cities of Santa Ana, Garden Grove, a small unincorporated area, and Westminster. These borders run right through neighborhoods. (Courtesy of Steve Bonhall.)

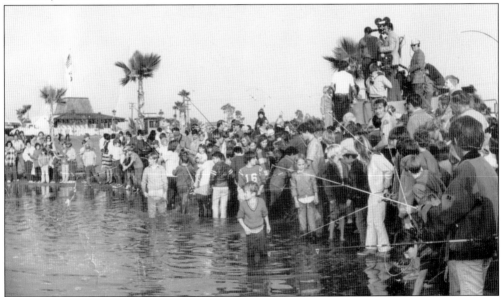

So anxious are these children to start fishing that some actually are standing in the water of the lake. Shortly after being stocked with trout, bass, catfish, bluegills, and crappie, the lake was closed until opening day. Note the news-camera teams on platforms on the upper right. Initially there were plans to make a zoo in the park. (Courtesy of Steve Bonhall.)

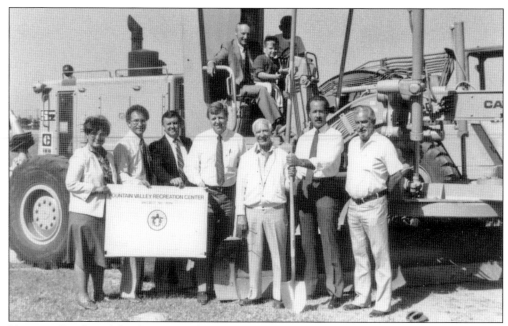

Various officials and developers stand in front of earthmoving equipment at this groundbreaking for Fountain Valley's recreation center. This was a 55-acre portion of the Mile Square area leased to the city from Orange County. Originally the city had planned to go directly to the federal government and request that a portion of Mile Square be deeded to the city for use as a park. However, it was later discovered that the county had a prior claim to the Mile Square surplus land. After completion, the park's dedication was on Saturday, June 28, 1975. (Courtesy of City of Fountain Valley.)

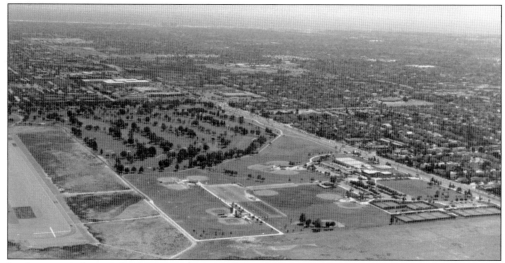

In this aerial shot of the recreation center, the tennis courts are on the right, the golf course is in the center, and on the lower left is one edge of the military landing strip. In the mid-1970s, the strip was used by hobbyists with remote-controlled airplanes and cars, kids with rocket kits, wind sailors, and various other people. At the top of this photograph, a faint image of the Edison power plant can be seen at Newland Avenue and Pacific Coast Highway. (Courtesy of City of Fountain Valley.)

Nine

ODDS AND ENDS

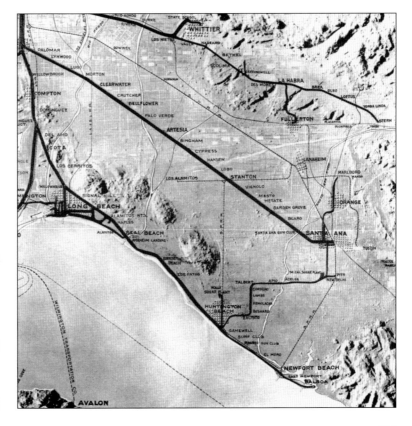

This is a map of the Pacific Electric Railway's Red Car line. The Red Cars traveled north on Bushard Street, turning east at Talbert and heading to Santa Ana. (Courtesy of Orange County Archives.)

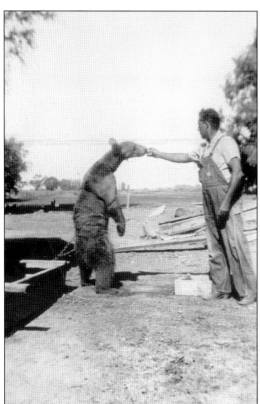

Joseph Betschart Sr., father of Louis and owner of the slaughterhouse in Talbert, is seen here with his pet bear, named Oscar. (Courtesy of Joseph Louis Betschart.)

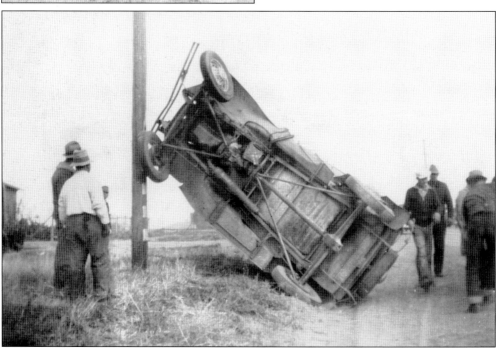

This 1930s photograph of a single-car accident in Talbert was talked about for years. (Courtesy of Joseph Louis Betschart.)

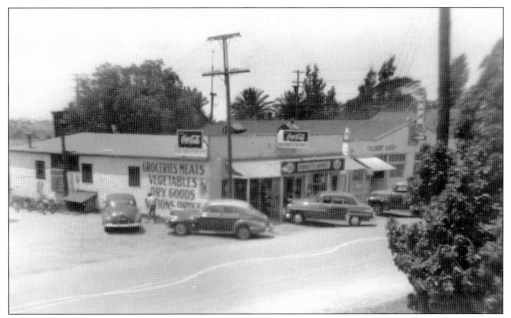

In this view, looking north on Bushard Street near Talbert Avenue, the grocery market can be seen. Note the wavy white lines through the center of the road. These could be found throughout the area and were painted as a warning to motorists that they were approaching an intersection. The lines were necessary all over the valley because of the regularity of heavy fog. (Courtesy of Wardlow family.)

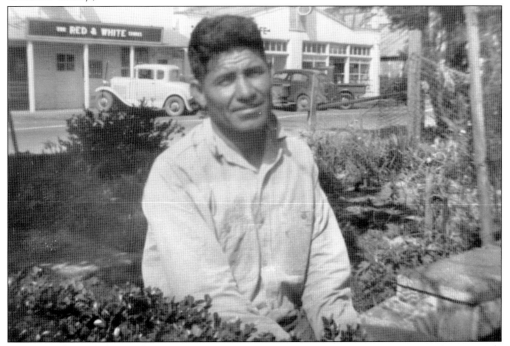

This is Tony Calderon in front of his home on Bushard Street, just south of Talbert Avenue. In the background next to the Talbert Café is the Red and White Store. (Courtesy of Nellie Calderon and family.)

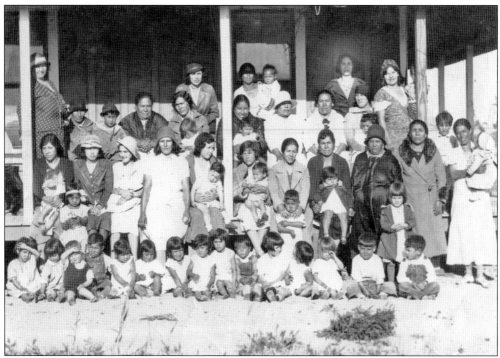

Pictured here is the community center in the Colonia Juarez in the 1930s. (Courtesy of Lillian Garcia.)

In the 1940s, the Orange County Health Department held a class at the Colonia Juarez community center. (Courtesy of Lillian Garcia.)

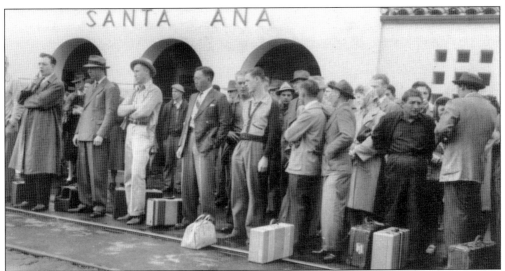

This is the train depot in Santa Ana during the peacetime draft prior to December 7, 1941, when the Japanese bombed the U.S. fleet at Pearl Harbor, provoking the United States to enter World War II. These men were inductees and were departing for basic training. The man in the center in a suit with his hand in his pocket is Charles Ishii, and to his left with arms crossed is believed to be Eldon Kanegae. (Courtesy of Jim Kanno.)

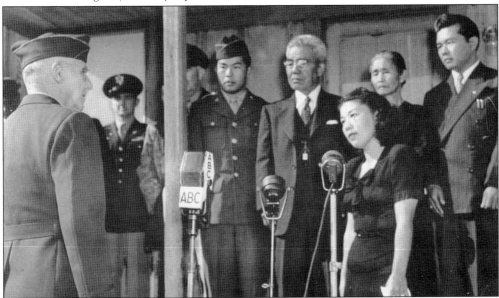

This ceremonial medal pinning took place on the front porch of the Masuda farm on Ward Street on December 8, 1945, for S.Sgt. Kazuo Masuda. Born in 1918 in Westminster, Masuda graduated from Fountain Valley Elementary School in the town of Talbert in 1932. He was a member of the famous 442nd Regimental Combat Team of the U.S. Army. The all-Japanese American unit, known as the "Nisei" regiment, fought in Italy and France and was the most decorated in U.S. history. Masuda was to be awarded the Distinguished Service Cross but was killed in action on August 27, 1944. The medal was to be awarded by Gen. Joseph W. "Vinegar Joe" Stilwell. In an unprecedented event, the four-star general traveled 3,000 miles to pin a posthumous award at someone's home, not at an army installation. Here the general addresses the family. (Courtesy of Mas Masuda.)

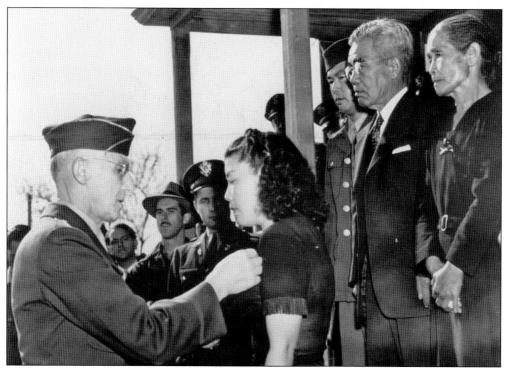

With family members looking on, General Stilwell pins the medal to Sgt. Kazuo Masuda's sister Mary, who moments later turned and pinned it onto her mother, standing behind her. (Courtesy of Mas Masuda.)

This is a shot taken just prior to the simple ceremony that Saturday morning. Also present at the ceremony was Capt. Ronald Reagan, an officer on the Americans Veterans Committee. This marked Ronald Reagan's first visit to Fountain Valley (Talbert). Note the camera crews on the right. (Courtesy of Mas Masuda.)

Later, after the medal ceremony at the Masuda farm, a ceremony titled "United America Day" was held at Eddie West Football Stadium in Santa Ana. In attendance were actor Robert Young and actress Louise Albrighton, among others. This photograph shows General Stilwell addressing the crowd. Earlier that day, Ronald Reagan gave what would become a famous speech. Years later, a bronze bust and a plaque with quotes from that speech would be placed at the stadium. (Courtesy of Mas Masuda.)

Here Will Rogers Jr. introduces General Stilwell to the audience. Years later, a Veterans of Foreign Wars post called the Kazuo Masuda Memorial VFW Post No. 3670 was established in Garden Grove. (Courtesy of Mas Masuda.)

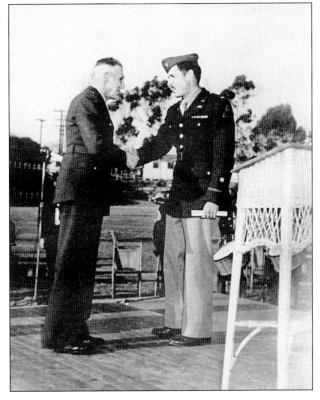

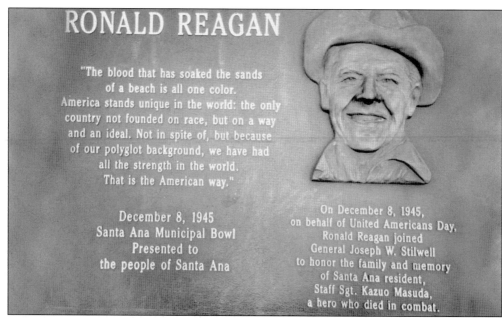

RONALD REAGAN

"The blood that has soaked the sands of a beach is all one color. America stands unique in the world: the only country not founded on race, but on a way and an ideal. Not in spite of, but because of our polyglot background, we have had all the strength in the world. That is the American way."

December 8, 1945
Santa Ana Municipal Bowl
Presented to
the people of Santa Ana

On December 8, 1945, on behalf of United Americans Day, Ronald Reagan joined General Joseph W. Stilwell to honor the family and memory of Santa Ana resident, Staff Sgt. Kazuo Masuda, a hero who died in combat.

Although no photographs were available of Ronald Reagan's speech at the "United Americans Day" at Santa Ana Municipal Bowl (now Eddie West stadium) on December 8, 1945, with General Stilwell, this plaque memorializes the event. Reagan was an officer of the Americans Veterans Committee at the time, and the quotation on the plaque is from that speech. The plaque refers to S.Sgt. Kazuo Masuda as a resident of Santa Ana, but that is a general term meaning the Greater Santa Ana Valley. Much the same way Orange County or Anaheim is sometimes referred to as the Greater Los Angeles area. The Masuda family lived on what are now Newhope Street and Warner Avenue, where Los Amigos High School is located. Since Santa Ana absorbed the town of Talbert's (Fountain Valley) post office in 1908, the Masuda's mail was rural free delivery (R.F.D.) out of Santa Ana. To this day, Fountain Valley's zip code, 92708, is still a Santa Ana zip. (Courtesy of Mas Masuda.)

This is the ribbon-cutting ceremony for the 405 Freeway completions through Fountain Valley in 1966. Seen here are, from left to right, Miss Fountain Valley, an unidentified woman, Mayor Robert Schwerdtfeger, a state highway official, Miss Costa Mesa, and Miss Huntington Beach. (Courtesy of City of Fountain Valley.)

This is the Fountain Valley city-promotion display on July 12, 1967, created for the opening of the Anaheim Convention Center. While others cities brought props for their displays, Fountain Valley utilized the existing fountain at the convention center. (Courtesy of City of Fountain Valley.)

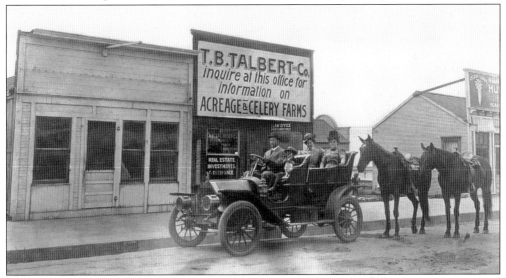

In May 1904, Tom Talbert, who started the post office on Bushard Street in 1899, moved to Huntington Beach and opened a real estate business. He wanted to capitalize on the Pacific Electric Railway Red Cars arrival, knowing the potential for customers that would be looking for land. This photograph is of his shop on Main Street in Huntington Beach. (Courtesy of First American Title.)

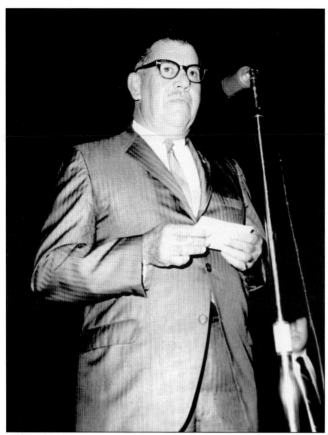

Acting mayor Joe Courreges addresses the crowd on opening night at Fountain Valley Drive-In, on July 12, 1967. Actress Raquel Welch is just off camera. The films shown this night were *Snow White and the Seven Dwarfs* and *Tammy and the Millionaire*. Also included in the festivities were circus clowns, "Santa in July," and local radio and television stars. (Courtesy of Hazel Courreges.)

This 1984 photograph was taken during the demolition of the drive-in. The official closing date was October 7, 1984. Part of the Pacific Theatre Group, this was the nation's largest drive-in. The screen was 140 feet by 90 feet and had a 2,000-car capacity. Initially there were night-lit water fountains along the front, but the common winds kept blowing the spouting water outside of the pools. That, along with kids putting laundry soap in the water, helped make the decision to turn them into planter boxes soon after opening. (Courtesy of John Koehler.)

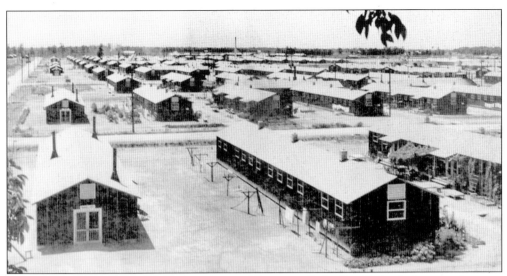

On February 19, 1942, President Roosevelt signed Executive Order No. 9066, which meant Japanese Americans on the West Coast would be relocated to camps throughout the west for the duration of the war. Over 100,000 Japanese Americans were affected by this order. This 1943 photograph of the camp in Jerome, Arkansas, shows the typical relocation-camp layout. The population at this camp was 8,500. This photograph, supplied by the Masuda family, shows the layout of the "blocks." The Masudas were housed in Block No. 15-03-D. Block No. 15 consisted of 12 of the structures pictured here. There was a common structure for washing and bathing, another structure for a mess hall, and one that served as a recreation hall. Jerome was the last camp to open, in October 1942, and the first to close in June 1944. It was then turned into a German prisoner-of-war camp. The Japanese Americans were relocated to the nearest camp, which was in Rohwer, Arkansas. Many of the Fountain Valley residents went to camp in Poston, Arizona, or in Gila River, Arizona. (Courtesy of Mas Masuda.)

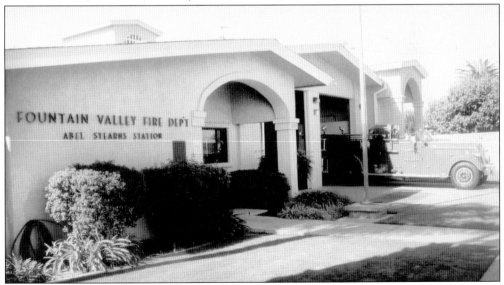

This is Fountain Valley Abel Stearns Fire Station No. 2, on Newhope Street, with a 1949 Seagrave fire engine out front. This truck was originally white when it was purchased from the city of Signal Hill. (Courtesy of author.)

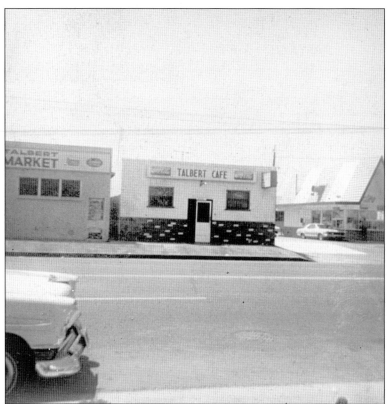

In the 1970s, this was how the Talbert Café looked. At the corner of Bushard Street and Talbert Avenue, where the blacksmith's shop once was, now stands a Pup and Taco drive-through restaurant. (Courtesy of Wardlow family.)

This 1970s photograph shows a typical scene after the Santa Ana winds blow through Fountain Valley. The tumbleweeds naturally piled up. Tumbleweed accumulation was a regular occurrence all over the valley until the vast fields were completely developed. (Courtesy of City of Fountain Valley.)

The city enters the annual Huntington Beach Fourth of July Parade, a near-century-long institution. Note the Huntington Beach High School tower in the background. (Courtesy of City of Fountain Valley.)

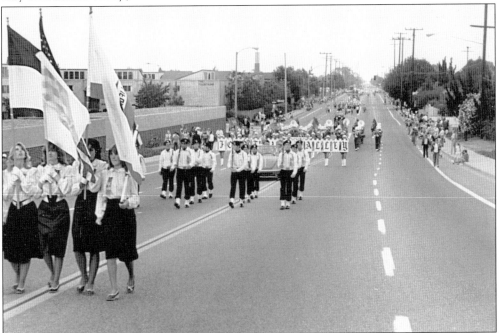

This 1981 shot looks south down the San Diego Freeway Bridge on Bushard Street toward Fountain Valley High School during a parade, which culminated at the recreation center on Brookhurst and Heil Streets. (Courtesy of City of Fountain Valley.)

This is Pres. Gerald R. Ford's motorcade arriving at the Fountain Valley Recreation Center. Actor John Wayne and President Ford stand through the sunroof of the limousine. This event was for President Ford's reelection campaign for 1976. (Courtesy of Gerald R. Ford Library.)

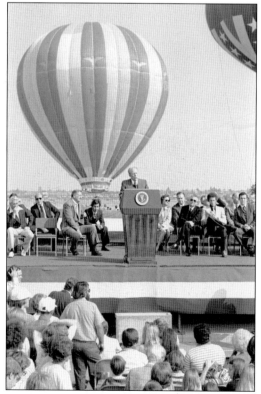

President Ford is seen here at the podium with John Wayne seated nearby. The president addressed the crowd with the Mile Square landing strip triangle in the background. (Courtesy of Gerald R. Ford Library.)

Ronald Reagan campaigned for president in Fountain Valley in 1980. Orange County has been a solid Republican area. Fountain Valley's location, at more or less the center of the county, made it an ideal place for this event. This was not Reagan's first time in the city. Note the parachutist landing in the background. (Courtesy of Penny Fujimura.)

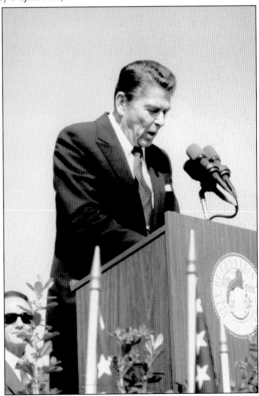

Here Ronald Reagan delivers his speech at the Fountain Valley Recreation Center to a large crowd. Note the city seal on the podium. (Courtesy of Ronald Reagan Library.)

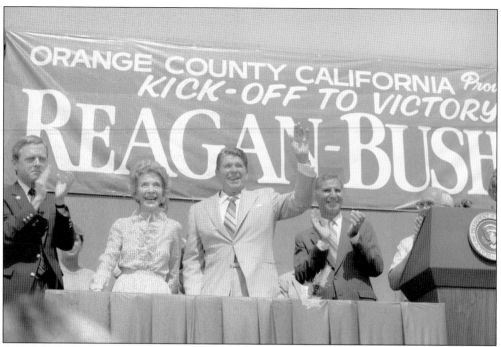

President Reagan and First Lady Nancy Reagan are seen on stage on September 3, 1984, in Mile Square Park. Reagan kicked off his 1984 presidential campaign in Fountain Valley. It was assumed to be poorly attended because it was on Labor Day Weekend. However, 58,000 people showed up, and 20,000 more were turned away, making it a huge success. In attendance were California governor George Deukmejian, as well as future governor Pete Wilson, celebrities, and other government officials. (Courtesy of Ronald Reagan Library.)

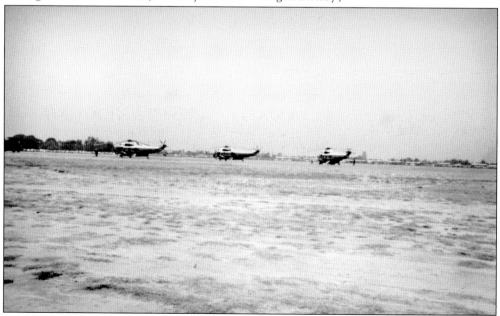

President Reagan lands in Miles Square Air Field. Seen here are the presidential helicopters. (Courtesy of Penny Fujimura.)

Fountain Valley's first mayor, Jim Kanno, is seen here with another political luminary. President Reagan's history with Fountain Valley dates back to 1945 and the Kazuo Masuda medal ceremony. (Courtesy of Jim Kanno.)

ADMIT ONE

ASIAN / PACIFIC AMERICAN
SALUTE TO THE PRESIDENT
Gate Open 9:30 A.M.
SUNDAY, JUNE 16, 1991

MILE SQUARE REGIONAL PARK, FOUNTAIN VALLEY
(Enter through Edinger Ave.)
Live Entertainment ■ Ample Parking

(See map on back) Organized By Asian/Pacific Coalition

This is a ticket to the 1981 Asian Pacific American Salute to Pres. George Bush at Mile Square Park. (Courtesy of Penny Fujimura.)

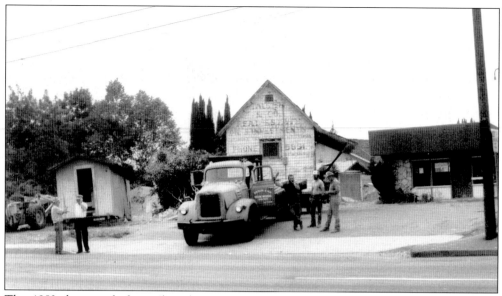

This 1982 photograph shows the relocating of the 1923 Talbert Real Estate office, which later became the local barbershop in the 1930s. It was being moved from this location on Bushard Street just south of Talbert Avenue, to its current location at Heritage Park, on Slater Avenue, next to the Fountain Valley Library. (Courtesy of Fountain Valley Historical Society.)

This is a 21st-century photograph of Heritage Park, which contains the restored Talbert Real Estate office, a 1930s Japanese bathhouse, and a 1930s tank house from the Callens ranch. This site belongs to the Fountain Valley Historical Society, the city, and the people of Fountain Valley. (Courtesy of author.)

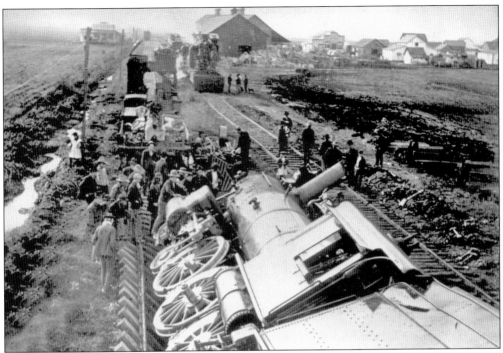

On January 13, 1905, Southern Pacific Engine No. 2215 fell over in this peat bog. The wrecking crew worked five days and nights to free the engine. In the background is the Smeltzer Community, sometimes referred to as the "Peatlands," near the intersection of Edinger Avenue (formerly Smeltzer Road) and Gothard Avenue. Smeltzer later became part of the city of Huntington Beach. This railroad track line ran north and south. Farmers who lived on the westerly side of Talbert (Fountain Valley) used this line as their nearest shipping point. (Courtesy of First American Title.)

This photograph depicts "Gospel Swamp" with all of its sycamores, tules, willows, and water. It was once known as—and later officially—Fountain Valley. (Courtesy of First American Title.)

ACROSS AMERICA, PEOPLE ARE DISCOVERING SOMETHING WONDERFUL. *THEIR HERITAGE.*

Arcadia Publishing is the leading local history publisher in the United States. With more than 3,000 titles in print and hundreds of new titles released every year, Arcadia has extensive specialized experience chronicling the history of communities and celebrating America's hidden stories, bringing to life the people, places, and events from the past. To discover the history of other communities across the nation, please visit:

www.arcadiapublishing.com

Customized search tools allow you to find regional history books about the town where you grew up, the cities where your friends and family live, the town where your parents met, or even that retirement spot you've been dreaming about.